IMAGES
of America

LAKE VIEW

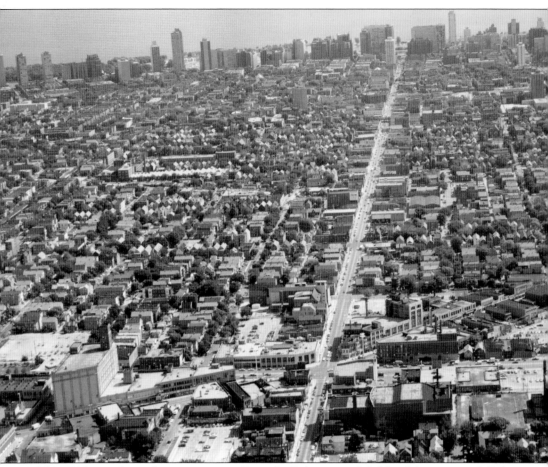

This 1983 view shows the intersection of Lincoln, Belmont, and Ashland Avenues, with Belmont Avenue running east from the bottom of the photograph to the top. In its heyday, the retail district was often touted as Chicago's busiest outside the Loop. That claim may be true, but it is hard to confirm. In 1948, a *Chicago Tribune* article stated that the district was ranked sixth in the city. It still did an impressive $52 million in business that year. (Courtesy of Central Federal Savings & Loan Association.)

ON THE COVER: Crowds at Lincoln, Belmont, and Ashland Avenues celebrate the opening of the Ashland Avenue Bridge over the Chicago River's north branch in 1936. A parade of historical floats that marched north from Sixty-ninth Street through the intersection marked the construction of the bridge, which connected the north and south sections of Ashland Avenue. (Author's collection.)

IMAGES
of America

LAKE VIEW

Matthew Nickerson
Foreword by Norman J. Dinkel Jr.

ARCADIA
PUBLISHING

Published by Arcadia Publishing
Charleston, South Carolina

Printed in the United States of America

Library of Congress Control Number: 2013941162

For all general information, please contact Arcadia Publishing:
Telephone 843-853-2070
Fax 843-853-0044
E-mail sales@arcadiapublishing.com
For customer service and orders:
Toll-Free 1-888-313-2665

Visit us on the Internet at www.arcadiapublishing.com

*This book is dedicated to my loving wife, Elizabeth,
and my children, John and Julia.*

CONTENTS

FOREWORD

At Dinkel's Bakery, now in our 10th decade, we are lucky to have played a part in Lake View's history.

Like the neighborhood itself, the workers at one time spoke German, and English was definitely a second language. I remember as a little boy seeing these craftsmen at work—they all had their "master baker" certificates from Germany. The key to our success was baking high-quality foods and selling them for a very affordable price. I remember the late Mr. Schmeissing of Schmeissing's Bakery telling me that bakers got together in the 1920s to figure out how Joseph K. Dinkel, my grandfather, could sell a coffee cake for 29¢ and make money when the other bakeries were selling theirs for 59¢.

Lake View was a good place for thrifty shoppers. At its heart was the Lincoln-Belmont-Ashland district, the largest shopping area outside the Loop. Many family-owned businesses catered to the community, like Kotz's Shoe Store, with an x-ray machine that you could put your foot in. Summer evenings would include cold cuts from Kuhn's Delicatessen and its famous potato salads. With rye bread from Dinkel's and beer, no one had to heat up a kitchen on a hot summer night.

The local parade on Friday, the day after Thanksgiving, would mark the busiest bakery day at Dinkel's. That was the first day of our annual fruitcake sale, and hundreds of people would wait before 6:00 a.m. for the doors to open. We would sell close to 50,000 pounds of fruitcake in 10 days!

And what about Christmas? I was told that in the 1920s, Christmas Eve for the Dinkel family would take place in my grandparents' apartment and was a black-tie event. This would take place after the store closed at 11 p.m. Cocktails would start at 1:00 a.m., and dinner would be served at 2:00 a.m. Boy, did those Germans know how to work and party!

So, turn off your cell phone, throw a blanket over the computer, and start enjoying the memories of our ancestors.

What were the issues and worries of the day? How were the Cubs doing? Did Uncle Johnny keep his job at the Parker Pen Co.? Did you hear about . . .

Let your imagination roll and enjoy the book!

—Norman J. Dinkel Jr.
2013

ACKNOWLEDGMENTS

The author usually does the lion's share of the work of a book. In this case, however, the book's subjects have done the work. Many contributors are acknowledged with photograph credits, and I acknowledge and thank them here again. For those whose names do not appear, know that I am grateful for your time.

Several people deserve special recognition: Jerry Haderlein, who was Teutonic in his diligence on this project; Jerry Gems, who was as quick to help as he was on the gridiron for the Lake View Sweepers; Chicago fire captain John Czerwionka, who went to the heights one would expect of his profession; Louisa and Edward Nickerson, who provided valuable editing; and Jim Pokryfke.

No book is possible without those who labor in the archives. Thank you to Julie Lynch of the Chicago Public Library, Kurt Potthast of the Lincoln Turners, the Illinois Historic Preservation Agency staff, Cathy Crino of St. Alphonsus Church, and Laura Abrahamson of St. Luke Church. Also, thank you to Margaret Schaffer for her translation.

Most of this book's historical narrative is based on others' research. I relied heavily, especially for the early history of Lake View, on *The Lake View Saga*, by Stephen Bedell Clark with Philip L. Schutt and with updates by Patrick Butler, Bill Breedlove, and Wayne Allen Salle. Other helpful works were Perry Duis's *Challenging Chicago*, Donald L. Miller's *City of the Century*, Patrick Butler's *Hidden History of Ravenswood and Lake View*, and various editions of the *Local Community Fact Book* and the *Chicago Tribune*. I also depended on the *Encyclopedia of Chicago*, edited by Janice L. Reiff, Ann Durkin Keating, and James R. Grossman.

Finally, thank you to Arcadia Publishing author Melanie Apel, Arcadia's Amy Perryman and Kelsey Jones, and of course Norman J. Dinkel Jr.

INTRODUCTION

Dan Buino grew up above the hardware store run by his father, Stanley, cut keys as a boy, and now runs the business from a perch overlooking shelves of nails, paint, and power tools. He has seen Lake View's history walk through his doors.

After World War II, German immigrants still set the tone for the neighborhood. Customers scolded Stanley Buino because he did not speak their language. By the 1970s, the store had no display windows because of a fear of a repeat of recent riots. By the 1980s, Buino was catering to landlords who were renovating apartments for the college graduates moving in. Today, Klein Hardware serves condominium owners who have bought those apartments and need a grill or a lightbulb. The immigrant families are gone, replaced by couples who have moved from Michigan or Ohio or New York, climbed a career ladder, and bought a home in one of the city's premier neighborhoods. They have made it, and so has Lake View.

When Buino was a youngster in the 1960s, Lake View was nearing the end of more than a century as a German-dominated community. The neighborhood was part of a strip that ran up Lincoln Avenue from Lincoln Park to Lincoln Square. There were clubs like the Turners, bars like Schulien's, politicians like Charlie Weber, and a string of delis, butchers, and beloved restaurants, from Schwaben Stube to Zum Deutchen Eck. Despite Lake View's reputation, many "German" residents were not actually German, but spoke German or were from a German borderland. In the mix were Austrians, ethnic Germans from Russia, Kashubs (from the disputed area around what is now Gdansk, Poland), and Swiss. In today's parlance, Lake View was a multicultural blend; it was just that many of the cultures were connected to Germany.

Lake View's Germanic roots date to its first European settler, Swiss-born Conrad Sulzer. The son of a minister, Sulzer studied medicine at the University of Heidelberg before immigrating to the United States. Sulzer first moved to upstate New York and then brought his wife and infant son to Chicago, buying 100 acres north of the city. In 1837, he built a house at what is now Clark Street and Montrose Avenue (once Sulzer Road). He was quickly joined by other immigrants, including a remarkable number from the tiny nation of Luxembourg. Many established vegetable farms and grew flowers in greenhouses, taking their produce into Chicago to sell to a growing and hungry city. The farmers proved so industrious that Lake View was billed as America's celery capital.

While settlers cultivated farms along Clark Street, the land remained barren along the lakefront. That changed when James Rees and Elisha Hundley built a resort hotel, Lake View House, in 1854, near what is now Grace Street and Sheridan Road. Legend has it that Walter Newberry, who endowed the Newberry Library, gave the hotel its name as he stood on the porch and gazed toward the water. "This is a delightful spot," the *Tribune* wrote of the hotel, "and one to which our citizens have flocked in large numbers since its first opening." The hotel beckoned Chicagoans to visit and look at property in Rees and Hundley's new Pine Grove subdivision, which lay south of it. The development proved popular, as prominent citizens built summerhouses to escape the heat and disease of Chicago. With rich residents on the lakefront and humbler ones to the west, a pattern was stamped on Lake View that would last until our times.

The lakefront resort area and the inland truck farms shared one weakness: each depended for its livelihood on selling to Chicagoans, making Lake View an appendage of the big city. Factories such as the Deering reaper and Northwestern Terra Cotta Co. plants started to locate along the Chicago River, however, creating jobs locally. Developers snapped up farms and subdivided them to sell to the workers pouring in, beginning the process of turning Lake View into a mature community.

In the early years, Lake View was a vast township stretching from Fullerton Avenue to Devon Avenue and from the lake to Western Avenue. With a booming population, it incorporated as a city in 1887, but the cost of providing schools and services overwhelmed it. Two years later, the infant municipality annexed itself into Chicago. Although Lake View was now part of the city, it actually was growing less dependent on Chicago. Industry boomed, a retail district grew at Lincoln, Ashland, and Belmont Avenues, and churches sprang up, meaning Lake View residents could work, shop, and worship without heading downtown.

Chicago's Lake View thrived in the new century, with Swedish, Irish, and other immigrants adding to the population. The community reached a population of 60,535 by 1910, only to increase again by more than 50 percent by 1920. Many institutions and businesses opened that would create fond memories for decades to come, including the YMCA, Dinkel's Bakery, the Belmont Theater, and Wieboldt's. The growth set the stage for the 1950s, the era that many remember today.

Nostalgia is dangerous for historical accuracy, but it cannot be denied that postwar Lake View had advantages. A man could find a job along the Clybourn, Ravenswood, and Lakewood Avenue corridors at companies like Appleton Electric and Cotter & Co. Willie Martinez arrived from Puerto Rico in 1953 and was hired in two weeks. He worked at Peerless Confection until 1995 and lived a short walk from the plant. Factory jobs that were stable and in the neighborhood were common.

Women could run a tab at their corner grocer and did not have to constantly worry about their children since other parents kept watchful eyes as well. "You knew everybody in the neighborhood," recalls Irene Borg. "I don't just mean to say, 'hello.' You knew their name." Those names grew more varied as Italians, Poles, and others joined the mix. Alan Fredian, an Italian American who grew up in the 1940s, recalls ethnic slurs being tossed around, but simply as slang, not as insults; a majority of the people got along most of the time.

By the 1960s, many in Lake View had started to seek better homes in the suburbs, or at least in neighborhoods farther out of the city. The area began to grow scruffy, and property values dropped, especially west of Broadway. Newcomers arrived, including Puerto Ricans and migrants from the South. A St. Josaphat Church yearbook even talked openly about the "white trash" that was moving in, pointing a finger at Southerners who developed a reputation, justified or not, for unruliness.

Nor were the established Lake View families without their troubles. Violence took its toll, touching young men like Jerry Gems, who grew up near Racine and Schubert Avenues. A feud started between his pals and rivals they accused of harassing neighborhood girls. The fighting was limited to fists, but then Gems got a warning. His cousin, visiting a pizza place at Webster and Sheffield Avenues where Gems's enemies hung out, overheard talk of getting a gun. "They were going to wait in my gangway at night and hit me then," Gems says. "I didn't go home for a while." He escaped by enlisting in the Marines. Everyone he knew wanted to leave the neighborhood, and he recalls driving through the North Shore, looking at the big houses. Gems now lives in Naperville, but his parents stayed in the area because they were attached to St. Alphonsus Church and their friends. Regardless of how tough the neighborhood got, a segment of the population was not going to leave.

While some stuck it out, many did not, and Lake View's population slid faster in the 1970s. As the years went on, business owners and home owners had to make hard choices. Some of the old German businesses, like Merz Apothecary and Kuhn's Deli, followed their customers to the north. At the Lincoln-Belmont-Ashland intersection, two major stores closed: Goldblatt's in 1985 and Wieboldt's two years later. Real estate agent Donald Haderlein moved his family to the Edgebrook neighborhood but decided to stick with his business. Haderlein considered himself "a Lake View

guy, through and through," his son John recalls, and felt he could survive the lean times. Others simply shrugged off the idea of moving out. "Where was I going to go?" Lawry Price says. "I had three children. I had a nice house."

Amid the decline, there were signs of underlying strength and resistance. Block clubs confronted gangs, the Lake View Citizens Council worked against blight, and the community was fortunate enough to lie in the path of gentrification as it marched north from downtown. Wrigley Field and two "L" lines that provided quick trips downtown drew childless professionals who were not worried about schools. There was also the feature that gave the neighborhood its name and its 19th-century influx of affluent homeowners; proximity to Lake Michigan continued to be a card Lake View could play.

Lake View drew celebrities like Joan Cusack, who bought a mansion in 1998 that was originally built for Conrad Sulzer's son. She sold it in 2007 for $4.7 million, dramatically demonstrating how property values had increased. People used to ask Norma Ehrenberg, "You're still in the old neighborhood?" Then, she says, they started to say, "I wish I was in the old neighborhood." Prosperity had its price though. Residents were less likely to know their neighbors, and some were priced out of the neighborhood. With the closing of factories like Stewart-Warner, there were few places to work anyway unless one was college educated. Blue-collar Lake View was on the way out.

Lake View's new residents work downtown in office buildings or elsewhere in the Chicago area. They shop at department stores on North Michigan Avenue or in the suburbs, not at Lincoln and Belmont Avenues. Lake View, the self-sufficient community where residents walked to work and to stores, has faded. For the first time since the 1800s, it is dependent on the city again. It is also no longer dominated by immigrants and their families. German or Spanish names on business signs are rare, replaced by names like Lululemon, Heritage Bicycles, and Perchance Boutique. For the first time since the Potawatomi Indians left, Lake View is a thoroughly American neighborhood.

Lake View's journey has taken it from a rural settlement, to a suburb, to a working-class city neighborhood, to an urban area on the decline, to a community of affluence. Along the way, the boundaries of what was called Lake View shrank from their expansive township lines to the current neighborhood's borders, commonly defined as stretching from the lake to the tracks along Ravenswood Avenue, from Diversey Parkway up to Irving Park Road east of Graceland Cemetery, and up to Montrose Avenue west of the cemetery. Many people traditionally identified themselves by their Catholic parish and did not concern themselves with neighborhood boundaries, so this book will not adhere rigidly to those borders. It will, however, focus on the western half of the neighborhood. East Lake View's ethnic patterns, nightlife, and expensive high-rises have long given it a different feel, and it deserves a history of its own. This book will focus on life around Lincoln and Southport Avenues. The history of the Clark Street, Halsted Street, and Broadway corridors will be chronicled in another book.

As much as Lake View has changed, reminders of its past lurk everywhere. A bust of Friedrich Jahn looks down from the old Turners hall, keeping an eye on Diversey Parkway. Neighbors along Lakewood Avenue live in townhouses that angle oddly because they follow the path of the old Milwaukee Road tracks. History even shapes what we taste: Dinkel's baked goods emerge from the same traveling-tray oven used in the 1940s. Our Lake View ancestors are with us still.

One

WORKING IN LAKE VIEW

With the 2013 announcement that Anderson Brothers would move, Alderman Thomas Tunney bemoaned the loss of Lake View's oldest business, a storage company that dates to around 1900; however, the alderman should have been reassured that the neighborhood boasts many enterprises of long vintage. One of Lake View's most venerable is Monastery Hill Bindery, which was founded before the Great Chicago Fire, although it did not move into the neighborhood until 1905. Unsurprisingly, Monastery Hill has a German heritage, like many of Lake View's oldest businesses. It also shares with them a willingness to evolve. In the beginning, the company bound books for leading families like the Palmers and the McCormicks. As the book industry changed, the bindery turned itself into a maker of menus for restaurants and hotels.

Many businesses have had to adapt to survive as Monastery Hill did. The decline of the Lincoln-Belmont-Ashland district put stress on the merchants around it, like Norman Dinkel Jr. of Dinkel's Bakery. "For years, I was waiting for the crowds to come back," he says. "They never came back." But, he and others shifted their tactics: Dinkel's Bakery expanded its mail-order business, D'Agostino's Pizzeria started to offer paninis, and the Ballin Pharmacy owner handed out cards at Fellger play lot to advertise nursing equipment.

It also has helped to be in a business with enduring demand and immunity to fads, such as diners, hardware stores, and of course funeral homes. One funeral business, Herdegen-Brieske, can trace its heritage back even further than Monastery Hill. It is in the building formerly occupied by P.A. Birren, the son of Heinrich Birren, a Luxembourger who entered the undertaking business in 1859.

There is another, often hidden, ingredient to long-term business success in Lake View: the owner's determination. Jerry Haderlein calls his father, real estate agent Donald, a "grinder." Steve Stauber does not want to stay open seven days a week, but he does. Philip Liss says that he had no analytical insight that kept Peerless Rugs going when the economy was challenging, but he knew failure was not an option. His secret? "I just worked."

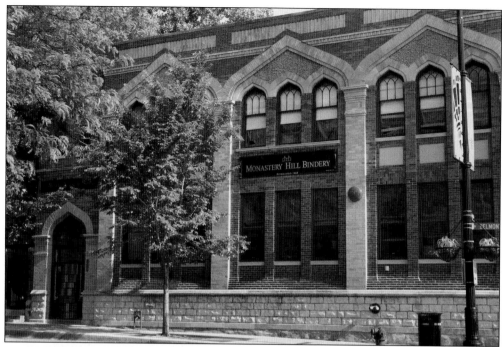

Ernst Hertzberg founded Monastery Hill Bindery in 1868, naming it after a place in his native Germany. The bookbindery profited from residents' need to restore their libraries after the Great Chicago Fire. Monastery Hill, on Belmont Avenue just east of the Union Pacific tracks, now concentrates on menu making and is led by Hertzberg's great-great grandson Blair Clark. (Photograph by author.)

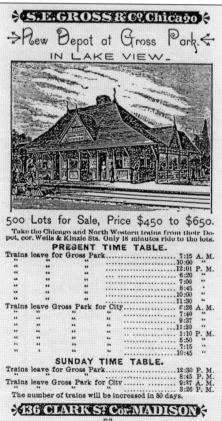

This advertisement by developer S.E. Gross boasts of the new train station in the Gross Park addition to Lake View. House hunters could take the Chicago & North Western train (now Metra's Union Pacific North line) to Belmont Avenue and find lots starting from $450. Samuel Gross, Chicago's greatest real estate man, had built more than 7,500 houses and developed more than 150 subdivisions by 1893, according to Donald Miller's *City of the Century*. (Courtesy of Central Federal Savings & Loan Association.)

Another of Gross's advertisements shows a slice of Gross Park west of the Chicago & North Western tracks and Gross Avenue (now Ravenswood Avenue). Gross, a man of many talents, also wrote a play called *The Merchant Prince of Cornville*. A federal judge later ruled that *Cyrano de Bergerac* was plagiarized from it; Gross accepted $1 to satisfy the complaint. (Courtesy of Central Federal Savings & Loan Association.)

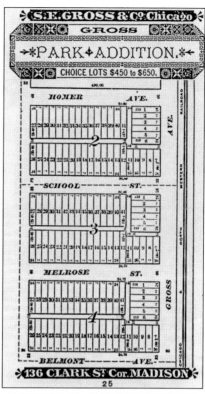

Frame Cottage No. 1, near Melrose Street and Lincoln Avenue, could be bought for a down payment and $20 monthly. In *City of the Century*, Donald Miller wrote, "Gross rarely foreclosed, shrewdly preferring to help families pay off cottages so that they could be induced to 'trade up' someday to a more spacious Gross house." Gross saw himself as the workingman's benefactor, and the Joint Labor Party nominated him for mayor. (Courtesy of Central Federal Savings & Loan Association.)

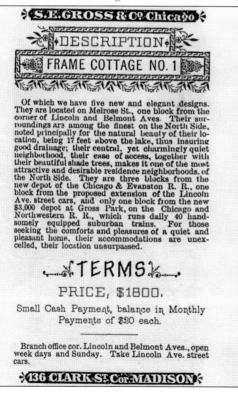

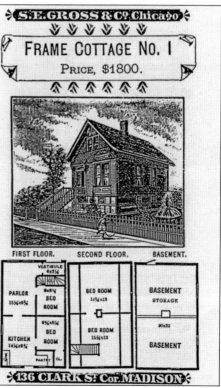

CHARTER AND BY-LAWS

OF THE

SVEA
BUILDING AND LOAN
ASSOCIATION

Incorporated under the Laws
of the State of Illinois

AUTHORIZED CAPITAL $20,000,000

SHARES $100 EACH

PRINCIPAL OFFICE
CHICAGO, ILLINOIS

PRESS OF S. TH. ALMBERG, 915-917 WELLS ST.

A quote from a 1918 board meeting of Svea Building & Loan Association, the forerunner of what is now Central Federal Savings & Loan Association, states, "Now let us firmly resolve that we will: work harder—squander less—save more." Svea, whose name reflected its customers' Swedish heritage, was founded in 1893. The bank renamed itself Central Savings to reflect what was then a downtown location. (Courtesy of Central Federal Savings & Loan Association.)

In 1957, the bank moved to 1616 West Belmont Avenue. Note the Fred Astaire Studios and Wieboldt's signs seen in the background. (Courtesy of Central Federal Savings & Loan Association.)

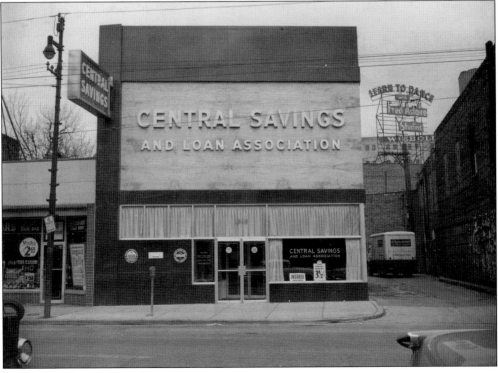

This money tree grew in the window at Central Savings. According to the bank, one early bank director, a Swedish immigrant named Nils Anderson, was held in such high esteem by Swedes that they would write to him about their children who had moved to Chicago, asking him to make sure they went to church and saved money. (Courtesy of Central Federal Savings & Loan Association.)

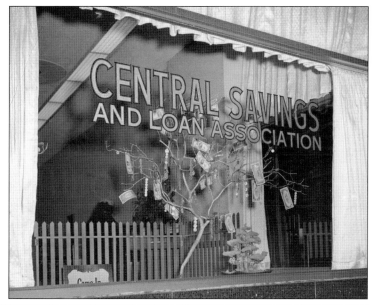

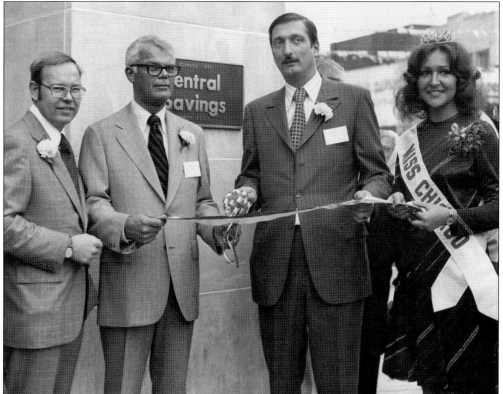

In 1974, Central Savings moved its headquarters east to 1601 West Belmont Avenue, the old Rothschild store. From left to right, executive vice president Jim Kosick, board chairman Richard Dahlquist, president Anthony Nichols, and an unidentified beauty queen cut the ribbon. Central Savings is still in this building today, and Nichols is still president. (Courtesy of Central Federal Savings & Loan Association.)

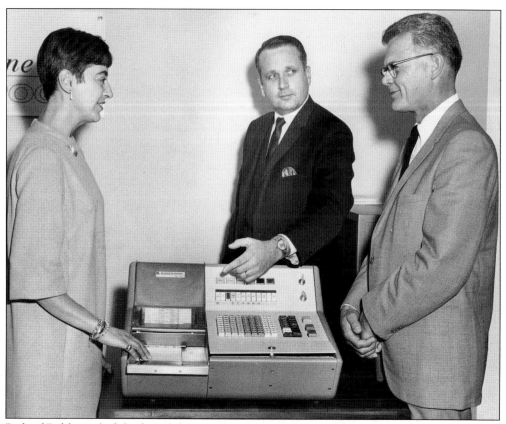

Richard Dahlquist (right), whose father was also a Central Savings official, talks with two others about one of the bank's teller machines. (Courtesy of Central Federal Savings & Loan Association.)

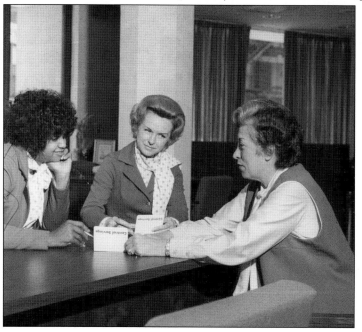

From left to right, an unidentified employee, office manager Joyce Andrews, and receptionist Tillie Cenlin confer at the 1601 West Belmont Avenue office in 1974. (Courtesy of Central Federal Savings & Loan Association.)

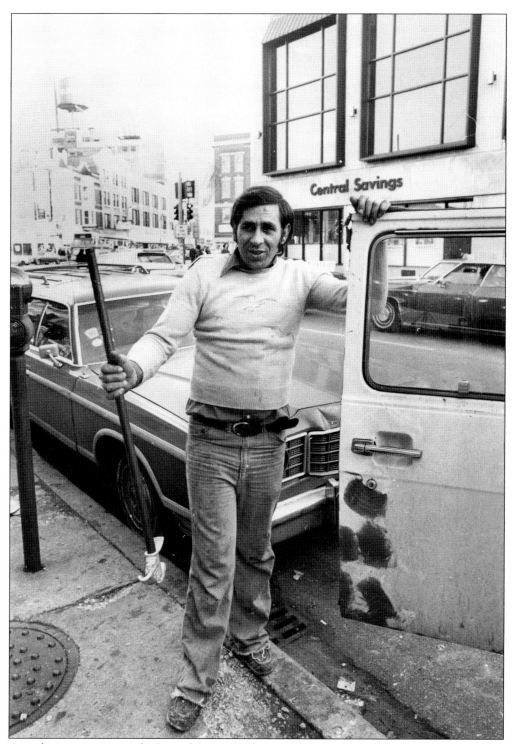

A workman arrives outside Central Savings. The Lincoln-Belmont-Ashland intersection in the background is a reminder of the days of "woodie" station wagons, full-sized automobiles, and coin-operated parking meters. (Courtesy of Central Federal Savings & Loan Association.)

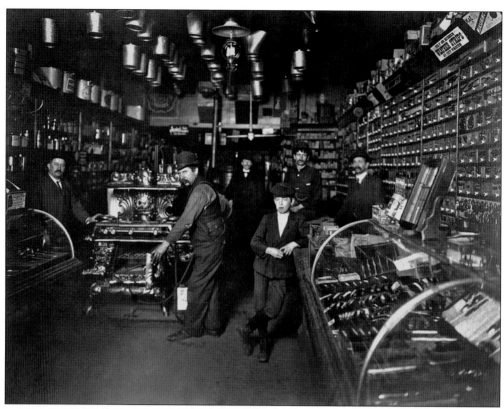

A very young William Stauber takes a break at his family's hardware store, founded in 1872 on Chicago Avenue near Larrabee Street. In 1906, Stauber Hardware moved to Lincoln Avenue near Byron Street, where it operates today. William grew up to join with other Chicago hardware store owners in founding the Ace cooperative in the 1920s. (Courtesy of Stauber Hardware.)

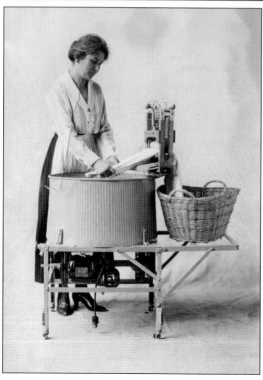

Lillian Stauber demonstrates a washing machine sold at Stauber Hardware. (Courtesy of Stauber Hardware.)

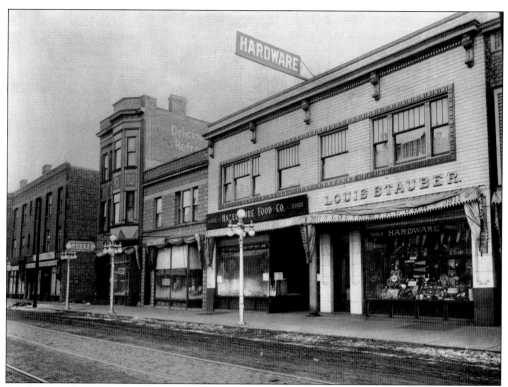

Stauber Hardware stands at 3911 North Lincoln Avenue between Hazel Pure Food Co. and the historic Krauspe Funeral Home (barely visible on the right). Hazel Pure Food was a chain of grocery stores. Krauspe later became Crosby Funeral Home and now houses Mrs. Murphy and Sons Irish Bistro. (Courtesy of Stauber Hardware.)

Stauber Hardware, after taking over the Hazel Pure Food space, celebrated its 60th anniversary in 1932. Steve Stauber, a great-grandson of the founder, says the store has survived by adapting. At one point, for example, it sold Harley-Davidson motorcycles. He also says that during the Depression the store might have swapped nails or a hammer for a pie. (Courtesy of Stauber Hardware.)

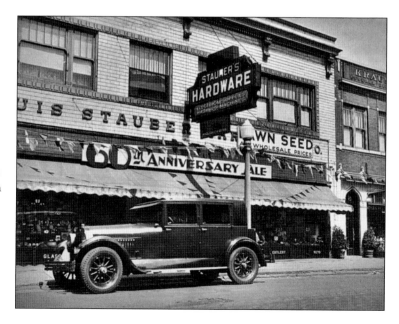

The Lincoln-Belmont-Ashland district used to be known for its extraordinary number of shoe stores; one businessman remembers counting 34 of them. Note the small sign advertising Hush Puppies. (Courtesy of Central Federal Savings & Loan Association.)

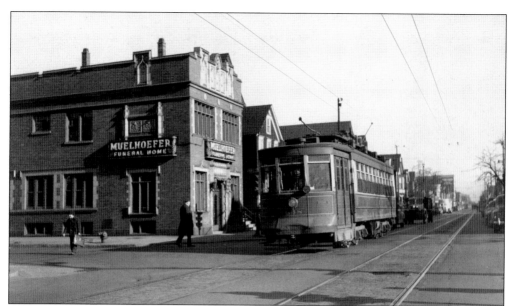

A streetcar heads west on Belmont Avenue in 1949, passing Muelhoefer Funeral Home. In 1971, Clyde Hallowell, who owned a funeral business on Lincoln Avenue, bought the business. Today, his son Ray and his daughter-in-law Kristine Hallowell run Lakeview Funeral Home along with Hiro Masumoto, who sold his funeral home on Clark Street. (Courtesy of Lakeview Funeral Home.)

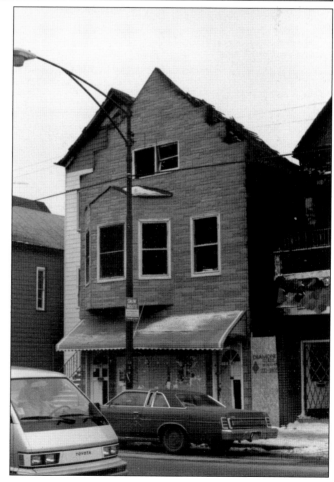

One could call this photograph Lake View at its lowest. A building at Belmont and Greenview Avenues burned in 1985 in what may have been arson. Building owners Ray and Kristine Hallowell, who also own the funeral home across the street, said they had complained about prostitutes and drug dealers and believe that the fire was set as revenge. (Courtesy of Ray and Kristine Hallowell.)

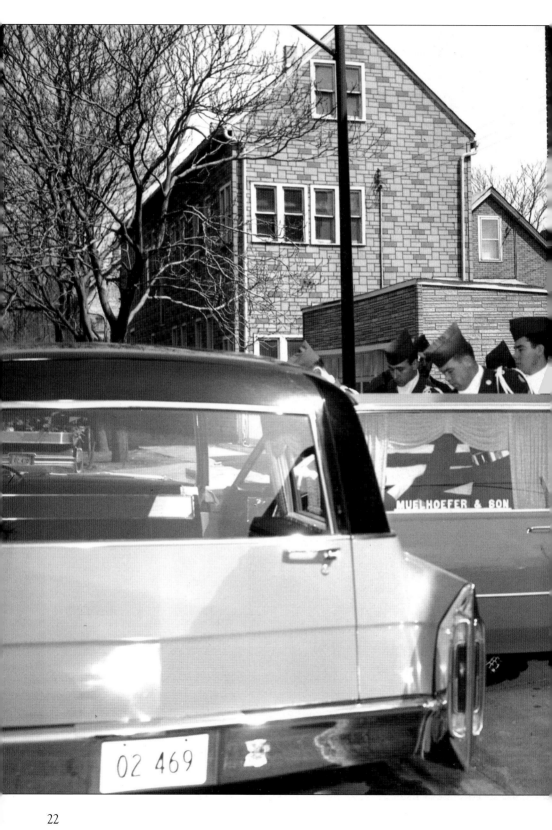

MUELHOEFER & SON

02 469

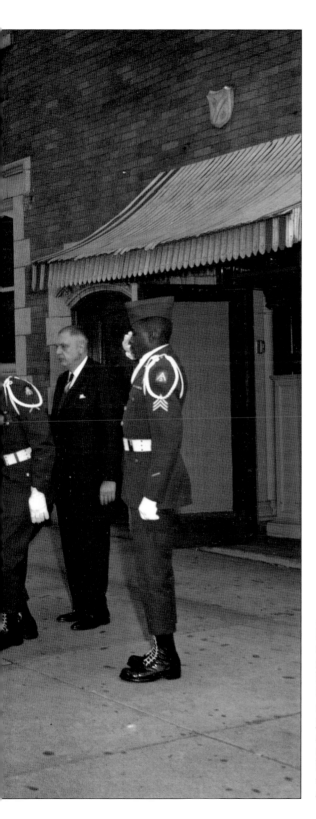

An honor guard helps at Muelhoefer Funeral Home. The name is gone today, but the funeral home still draws from the historic German population at St. Luke Lutheran Church across the street. When Hiro Masumoto joined, he added a Japanese American clientele, a presence acknowledged with incense burners for Buddhist funerals as well as Japanese art. (Courtesy of Lakeview Funeral Home.)

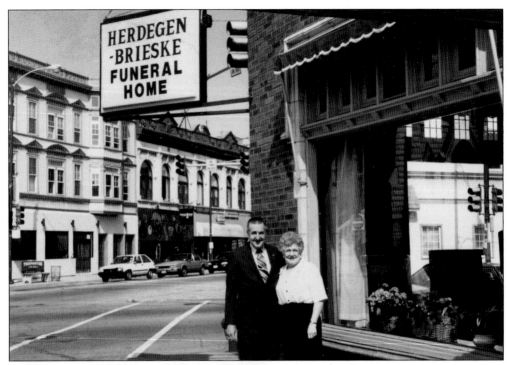

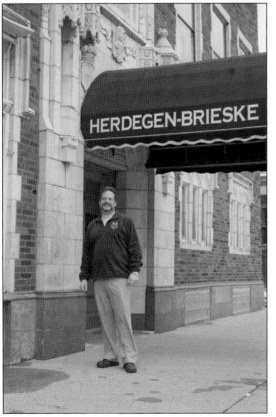

William and Maureen Herdegen pose for a photograph around 1988 at their funeral home, a product of Lake View's many funeral home closings and consolidations. Herdegen bought George Westfall's business, at 2838 North Lincoln Avenue, in 1957. Then, in the 1980s, he bought the Brieske business (but not the building) and the Birren building (but not the business), creating Herdegen-Brieske, at 1356 West Wellington Avenue. (Courtesy of Joseph Herdegen.)

Today, Joseph Herdegen carries on his father's legacy. He recalls that his father would give discounts to the poor and was known as the rare funeral director in the 1980s who would take AIDS victims. Times now are tough though, as the same influx of young residents that benefits other businesses only hurts funeral homes. (Photograph by author.)

Slemon Yonan received an honorary sign in 2002 on the occasion of the 50th anniversary of his business, Tiger's Body Shop, at Lincoln Avenue and Addison Street. From left to right are his son Scott, daughter Julie, Slemon, his son Greg, his grandson Daniel, and Alderman Gene Schulter. Yonan, an Assyrian immigrant, got his nickname for playing football "like a tiger" at Waller High School. (Courtesy of Tiger's Body Shop.)

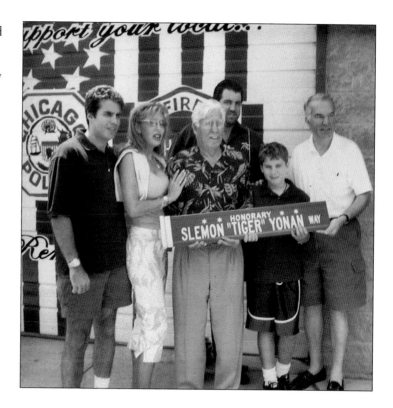

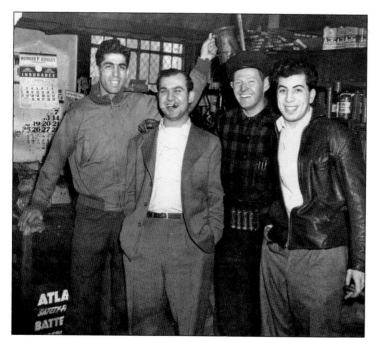

Slemon Yonan (left), seen here at a garage in 1948, came to America as a boy as his family fled violence in Iraq. Slemon's cousin, the late Zodak Yonan, a longtime 44th Ward worker, has his own honorary sign at Oakdale and Sheffield Avenues. Zodak resigned from his job after the *Chicago Tribune* reported he was avoiding paying parking meters, but his family stressed that he served the ward for years and raised money for Agassiz School. (Courtesy of Tiger's Body Shop.)

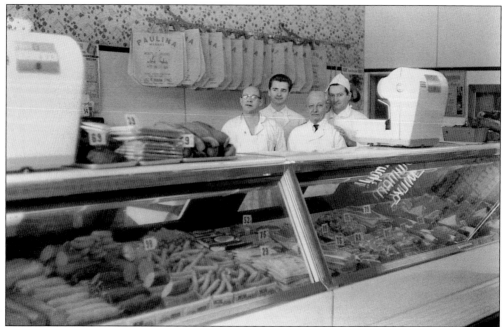

The owner and crew of Paulina Meat Market pose when the store was at Paulina and Lincoln Avenues in 1949. That year, the original German proprietor of the business (left) sold it to Sigmund Lekan (not pictured), whose family came from the borderlands between Poland and Prussia. Lekan spoke only a little German, prompting many to predict that his business was doomed, his son Jerome recalls. (Courtesy of Paulina Meat Market.)

In 1983, the Lekans moved their butcher shop to a building twice the size at Cornelia and Lincoln Avenues. Jerome Lekan says he advocated moving out to Barrington, but his father and brother decided to stay, even as customers left the neighborhood. The decision paid off, as the market is now the darling of foodies, although Lekan scorns the words "gourmet" and "boutique." (Courtesy of Paulina Meat Market.)

Jim Zavacki is seen here working at Paulina Meat Market. In the old days, Jerome Lekan says, German women would shop on Saturday and always wanted the same things: baloney sausage, liver sausage, and blood sausage. Now, he says, customers are looking for different flavors, and the store has adapted to appeal to them. (Courtesy of Paulina Meat Market.)

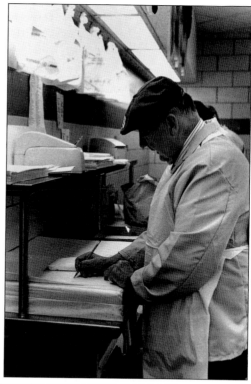

The Paulina crew takes a break, including Jerome Lekan (kneeling, left) and his uncle Carl Lekan (center, in the dark jacket). The Lekans sold the business to former manager Bill Begale, but Jerome still works there, and the market keeps the same standards. "We try to do things the right way, which to me means perfect," Jerome Lekan says. (Courtesy of Paulina Meat Market.)

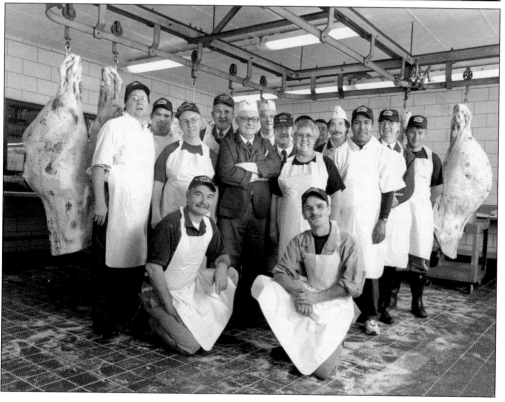

Peerless Rug, seen here in the 1950s, was founded in 1938 by Milton Liss on the west side of Lincoln Avenue, north of Wellington Avenue. Philip Liss, Milton's son, has weathered many ups and downs. "I could pay the bills; I couldn't pay the bills. I did well; I didn't do well," he recalls. But, he kept working: "It didn't occur to me that I wouldn't be here." (Courtesy of Peerless Rug.)

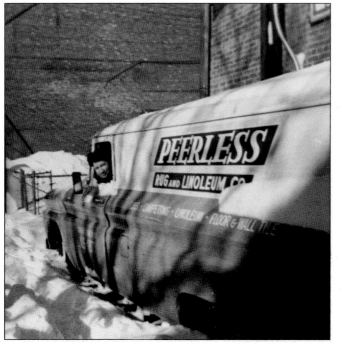

The Peerless truck is seen here in a 1967 snowstorm. In the next decade, Peerless moved across the street to its current location, at 3033 North Lincoln Avenue, the site of an old movie house. Philip Liss remembers watching Tom Mix films there as a boy while his parents worked at the store. (Courtesy of Peerless Rug.)

Schubas Tavern, at Southport and Belmont Avenues, has preserved its Schlitz sign, which indicates it was once a "tied house." Brewing companies around 1900 built and controlled their own bars, which sold only their products. Other Schlitz tied houses include the building that now houses Southport Lanes and a building at Belmont Avenue and Leavitt Street. (Photograph by author.)

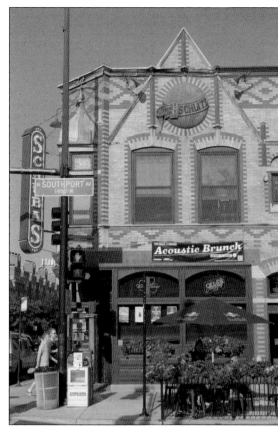

Southport Lanes claims the distinction of being one of 10 bowling alleys left in America with hand-set pins. Originally a bar, in 1922 the establishment put in four bowling lanes to mask the fact that it was a speakeasy and a house of prostitution, current owner Steve Sobel told the *Tribune*. Its Schlitz sign also marks that it was a tied house. (Photograph by author.)

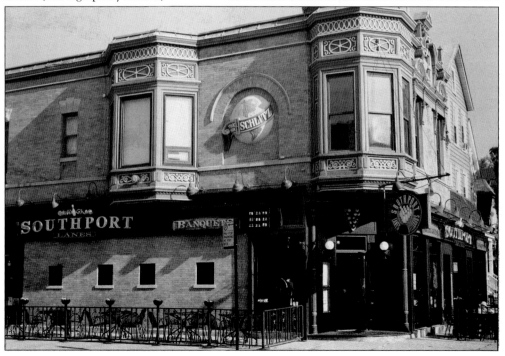

The Tenenbaum Hardware crew assembles in the early 1950s. From left to right are an unidentified worker, Sondra Tenenbaum, Sondra's father Herman Tenenbaum, two unidentified workers, and family member Irving Sandler. Herman, who started by selling hardware out of the trunk of his car, opened the store at 1138 West Belmont Avenue in 1923. (Courtesy of Tenenbaum Hardware.)

The founder's daughter, now Sondra Lipshutz (center), helps reopen the store in 1970 after it was ravaged by fire the year before. Sondra's husband, Morrie Lipshutz, is standing behind her, just visible. Their son Steve remembered how his father reacted to the fire. "He was pretty calm about it," Steve said. "He just kept going to work." (Courtesy of Tenenbaum Hardware.)

Morrie and Sondra Lipshutz enjoy reopening day. Morrie spent most of his time at the store, so in order to see him his children spent Saturdays working there. When they got hungry, they would eat at the diner across the street in window seats, with Morrie watching through the store window as he worked. (Courtesy of Tenenbaum Hardware.)

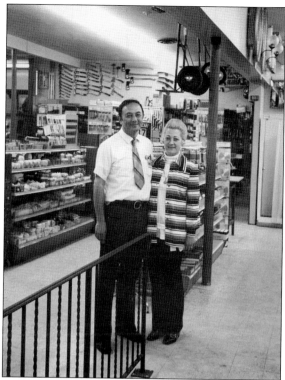

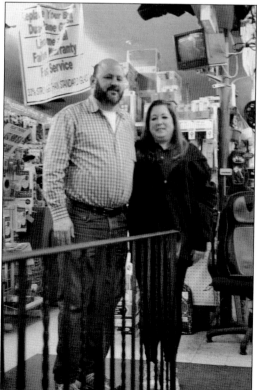

Steve and Pam Lipshutz strike their parents' pose 43 years later. Steve's big thrill came when the Chicago Cubs called him with an urgent job: Andre Dawson's foul ball the day before had cracked the WGN dugout camera's protective glass and wondered if he could replace it. After Steve rushed over, he got to take a seat with the players and watch batting practice. (Photograph by author.)

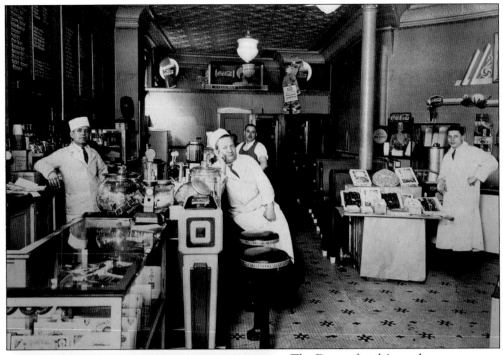

The Demas family's candy store is seen here around 1935 at 3000 North Lincoln Avenue, the space that is now S&G Restaurant. (Courtesy of S&G Restaurant.)

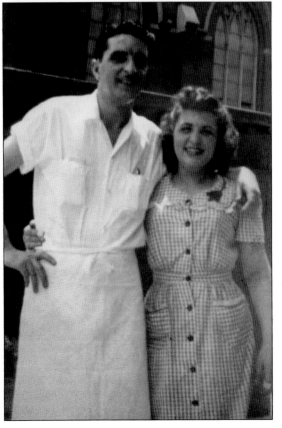

After the candy store closed, the space was home to a diner run by Jimmy James, seen here standing outside the restaurant in 1955 with his wife, Patricia. St. Alphonsus Catholic Church is in the background. In 1957, Sam and George Boudouvas bought the restaurant, creating S&G. (Courtesy of S&G Restaurant.)

George Boudouvas, seen here working behind the counter in 1999, runs S&G Restaurant today. The Greek immigrant says that America has been good to him, and he notes that he works "seven days a week like a dummy" and has expanded the restaurant without ever being given anything. (Courtesy of S&G Restaurant.)

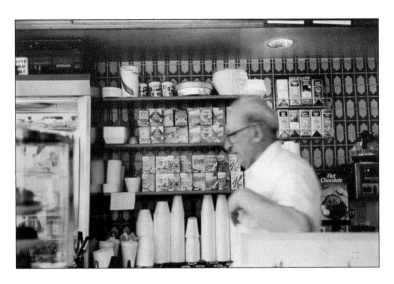

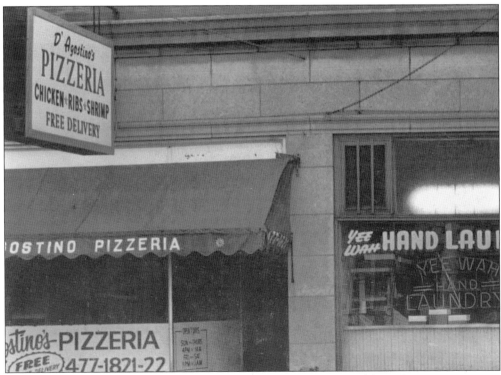

D'Agostino's Pizzeria, seen here in 1972, started in a storefront on Addison Street as a carryout place. Profiting from business from the old Cooney Funeral Home, Joe D'Agostino expanded to take over the space occupied by the laundry seen here, eventually buying the building and adding four locations. The old D'Agostino's Amoco at Irving Park Road and Broadway was run by a relative of Joe's. (Courtesy of D'Agostino's Pizzeria.)

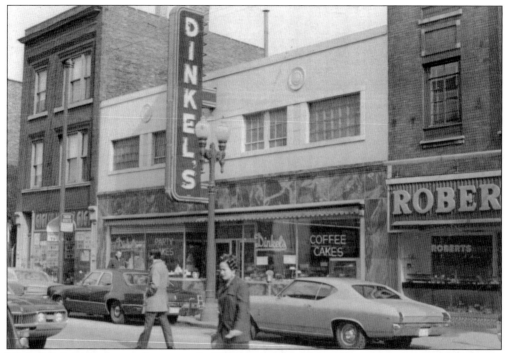

Dinkel's Bakery has been a fixture on the 3300 block of North Lincoln Avenue for nearly a century. The bakery was originally across the street, where Rexx Rug is now, and was called Hopfner's Bakery. Joseph Dinkel, a Bavarian immigrant, bought it in 1922. (Courtesy of Dinkel's Bakery.)

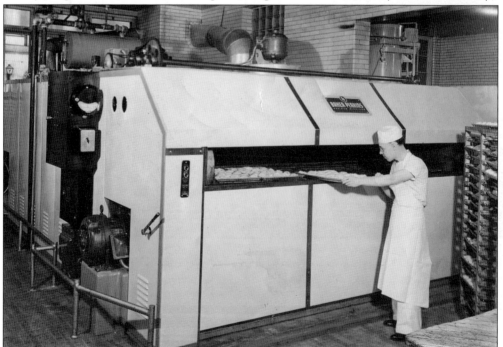

A worker tends Dinkel's 13-tray Baker Perkins oven in 1944. Dinkel's still uses the oven, which Norman Dinkel Jr. said yields a better product than a forced-air oven. (Courtesy of Dinkel's Bakery.)

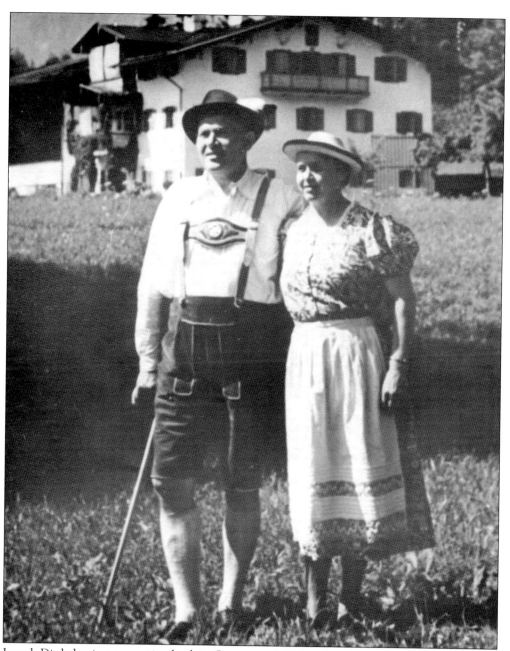

Joseph Dinkel enjoys a vacation back in Germany with his wife and business partner, Antonie. For many years, the bakery workers were German, his grandson Norman Dinkel Jr. said. They would arrive early in the morning in coats and ties and then change into their work clothes. At lunch, they would drink Schlitz beer and eat sausages sitting on benches. (Courtesy of Dinkel's Bakery.)

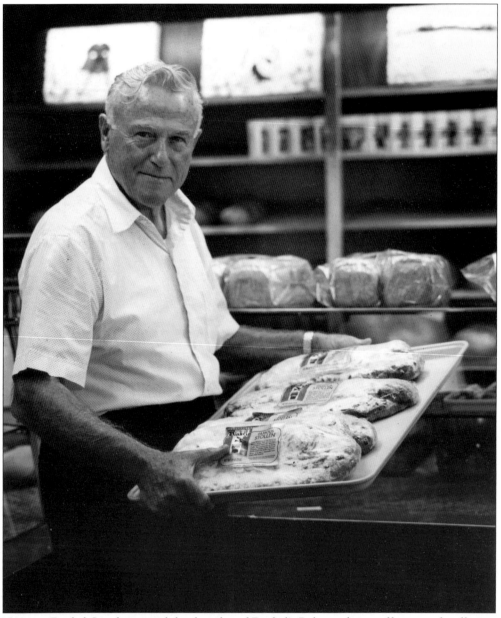

Norman Dinkel Sr., the son of the founder of Dinkel's Bakery, shows off a tray of stollen in the 1980s. He had not wanted to take over the business, but his father, Joseph, was shot in a holdup on a Saturday night. Joseph survived, but he needed Norman Sr. to step in. (Courtesy of Dinkel's Bakery.)

Norman Dinkel Jr. poses in the 1980s with mail-order goods and his daughters Jenny (left) and Sandy. At one point, a consultant advised that they move to Arlington Heights, but Dinkel's stayed put, getting a lift from side businesses like mail order, which picked up steam after Dinkel's was featured on the Food Network. Over the next three days after the appearance, Norman Jr. remembered 5,000 calls came in. (Courtesy of Dinkel's Bakery.)

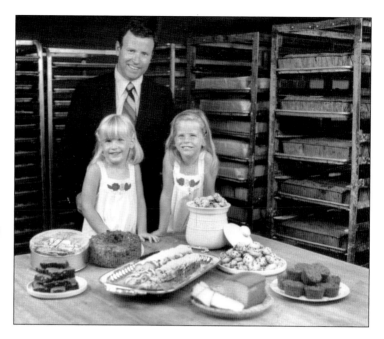

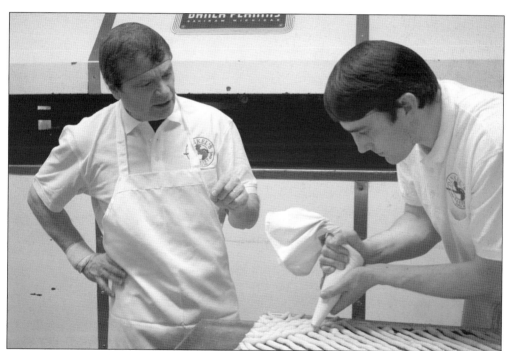

US representative Mike Quigley (left) tried his hand as a baker recently with the help of Luke Karl, who married Sandy Dinkel and is helping carry Dinkel's into its fourth generation. The bakery has survived many changes, such as the decline of the Lincoln-Belmont-Ashland district. "I think Dinkel's is selling stability and nostalgia in an unstable world right now," Norman Jr. said. (Photograph by author.)

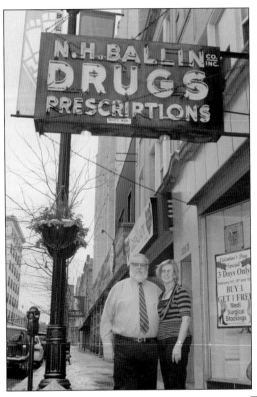

Bill Mattson runs Ballin Pharmacy with his wife, Louise. He started working there at age 15 in 1966 and eventually bought it from Norman Ballin's son-in-law. With stiff competition from chains, the Mattsons do not sell cards or cosmetics, instead focusing on drugs, surgical supplies, and nursing products. Another key, Mattson says, is operating a second business out of the basement and owning his own building. (Photograph by author.)

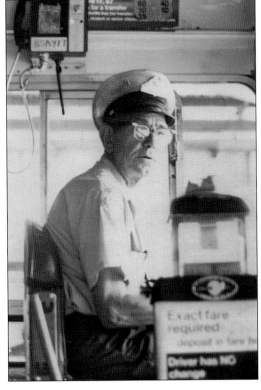

Lake View resident Haron Rambo drove Lincoln Avenue buses for the Chicago Transit Authority. A Tennessee native, he came to Chicago after World War II to find work. He resented news stories in the *Tribune* in the 1950s that he viewed as unfairly blaming Southerners for social problems. "We did not have a *Chicago Tribune* in the house after that," his daughter Rita Lake says. (Courtesy of Rita Lake.)

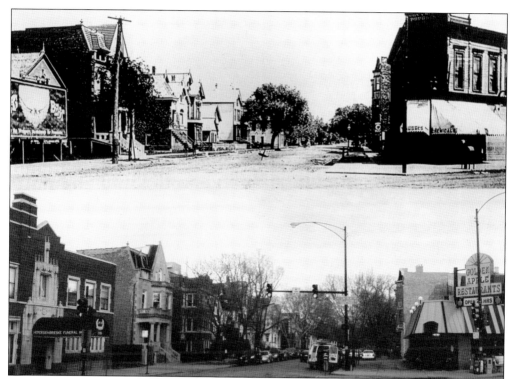

These two photographs, one taken in 1910 and the other in recent years, look east down Wellington Avenue with Lincoln Avenue stretching left and right in the foreground. In 1910, an apothecary shop stood at the corner where the Golden Apple is now, according to the diner's co-owner Nick Alexopoulos. The restaurant opened in 1954 as the Golden Nugget and later changed names and ownership, although other Nuggets continued to operate. (Courtesy of the Golden Apple Grill & Breakfast House.)

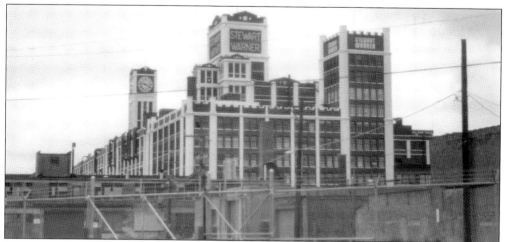

The Stewart-Warner plant, at 1826 West Diversey Parkway, once employed as many as 2,000 people. Its clock tower made it a landmark. Stewart-Warner made car speedometers and was founded by the same men who started the company that later became Sunbeam Bread. The factory, which closed after the company was sold in 1987, was replaced by a housing development. (Courtesy of Harry Blesy.)

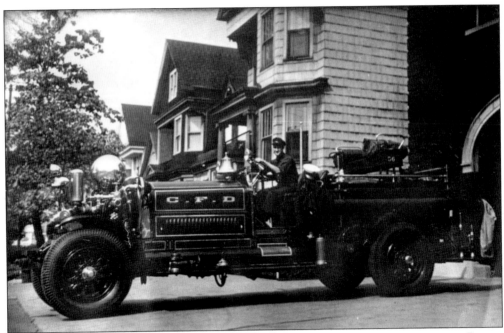

Fireman Joe ? shows off new equipment at Engine 56, located at 2214 West Barry Avenue. Engine 56 started at 2628 North Southport Avenue in 1889 but moved to a wooden building on West Barry in 1893. In 1936, a brick firehouse replaced the wooden one, and it still stands today. (Courtesy of Engine 56.)

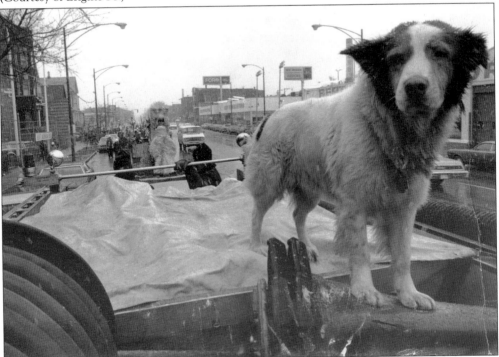

Engine 56's mascot Sam enjoys the parade as it heads south on Ashland Avenue past Bert Weinman Ford. (Courtesy of Engine 56.)

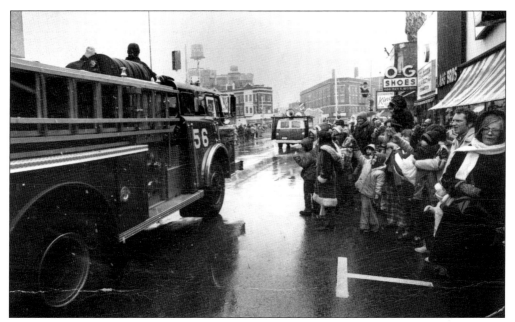

Engine 56 takes part in a parade heading toward the Lincoln-Belmont-Ashland intersection. (Courtesy of Engine 56.)

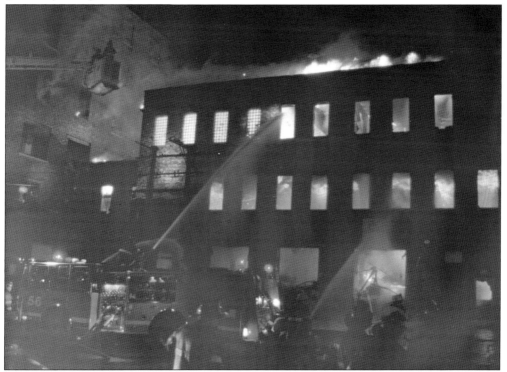

A fire rages at 1825 West Diversey Parkway in this undated photograph. It was a 5-11 alarm, indicating a very serious fire, and it may have been one of the blazes in late 1992 and early 1993 that destroyed connected buildings at 1775–1825 West Diversey Parkway. (Courtesy of Engine 56.)

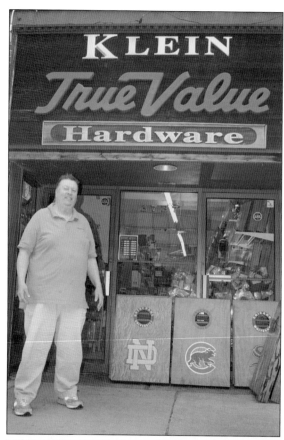

Dan Buino stands outside his Klein True Value Hardware store, at 3737 North Southport Avenue, in 2013. His father, Stanley Buino, bought the store from Karl Klein in 1946. Dan recalls that German immigrants accustomed to shopkeepers speaking their language would grow annoyed with the elder Buino, who was Polish American. "Customers literally called my dad a 'dummkopf' [blockhead]," he says. (Photograph by author.)

Gentrification sometimes has its price; when a new building went up next door in 1995, the work collapsed part of Klein Hardware's north wall, as seen here. The store was once a horse-and-wagon barn for Bowman Dairy (now Dean Foods) and then a roller rink and factory, according to Buino. (Courtesy of Klein Hardware.)

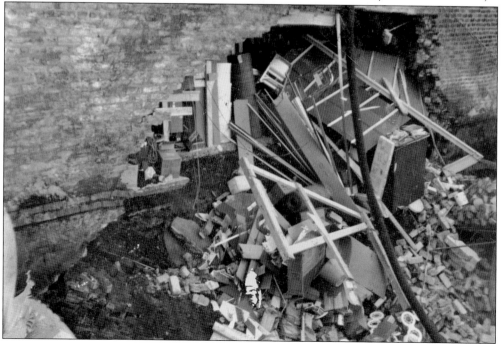

Two

LEARNING IN LAKE VIEW

Lake View High School is touted as the state's oldest public high school—the claim has been well defended. Historian Helen Zatterberg wrote a letter to the *Chicago Tribune* in 1940 taking issue with another school that claimed to be the oldest. She cited documents and maintained that the Ravenswood-Lake View Historical Association could offer more proof if skeptics asked for it. There was really little doubt as to the school's antiquity. It opened in 1874, built on land given by Graceland Cemetery.

Lake View High School initially allowed only eight students to enroll after administering exams to 73 children. Today, Lake View enrolls 1,500 students and boasts an alumni list with a remarkable number of famous people, particularly entertainers. Among Lake View's former students are ventriloquist Edgar Bergen, silent movie actress Janet Gaynor, film actress Gloria Swanson, television actor Tom Bosley, and Harlem Globetrotters owner Abe Saperstein, as well as writer John Gunther, surgeon Philip Thorek, Alderman Gene Schulter, and US representative Sidney Yates. In keeping with the Hollywood theme, the school was also the setting for the 1980 movie *My Bodyguard*.

As an independent community, Lake View opened its first public schools separately from Chicago. In those early days, Lake View's leaders built, along with the high school, eight grade schools, including one at Seminary Avenue and Diversey Parkway in 1878, and one in 1882 at Ashland and Wrightwood Avenues. Today, the Lake View neighborhood has 10 public elementary schools.

Apr. '41.

Adjustment Class.

Pictured in 1941, Hamilton School students practice writing in what was called adjustment class. By the 1970s, a *Chicago Tribune* columnist had identified Hamilton, at 1650 West Cornelia Avenue, as the center of the Simon City Royals' gang turf. The school and area have changed rapidly; by 2012, a total of 82 percent of Hamilton students met or exceeded state academic standards. (Courtesy of the Chicago Public Library, Sulzer Regional Library, RLVCC 20.33.)

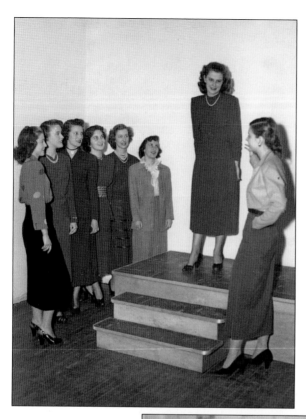

Lake View High School students pick a prom queen in 1949. The *Chicago Tribune*'s "inquiring camera girl" asked six Lake View students that year if parents should set a curfew on prom night: five said no, and one, Larry Ascher, said yes—but only for girls. (Courtesy of the Chicago Public Library, Sulzer Regional Library, HDG 2.126.)

Lake View students take part in a home economics class in 1974. A century before, students read Cicero and Virgil and studied Greek, chemistry, trigonometry, zoology, natural philosophy, and English literature. (Courtesy of the Chicago Public Library, Sulzer Regional Library, LVHS 3.21.)

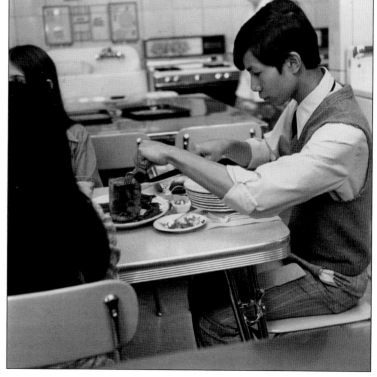

Today, Agassiz School, at 2851 North Seminary Avenue, looks similar to what is seen in this photograph. Founded in 1912, it was named after Louis Agassiz, a naturalist who pioneered the study of ice ages. Agassiz's belief in white racial superiority later marred his reputation and led to the renaming of an Agassiz School in Massachusetts. As of 2013, Chicago's Agassiz School was discussing whether to adopt a new name. (Courtesy of Agassiz School.)

Agassiz School eighth-graders pose for a photograph in 1958. In the 1980s, the school survived a proposal to close it. Today, it is a combination of a neighborhood school and a fine- and performing-arts magnet school. In the past, students were bused in from as far away as the South Side, but now the enrollment of neighborhood kids is rising as Lake View's young professionals have children. (Courtesy of Agassiz School.)

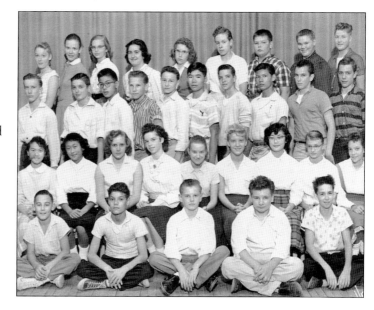

This Agassiz School newspaper from June 1938 paints an attractive picture of the summer vacation to come. (Courtesy of Frank DiBenedetto.)

Homemade costumes dominated Halloween in 1946 at Jahn School, at Belmont and Wolcott Avenues. The girl standing on the far left, dressed as a pumpkin, is Carole Kulzer. She was one of two first-graders picked to join a parade around the neighborhood. "I was over the top about being selected, but my mother, who sewed the outfit, was probably more thrilled than I," she recalls. (Courtesy of Carole Kulzer Brennan.)

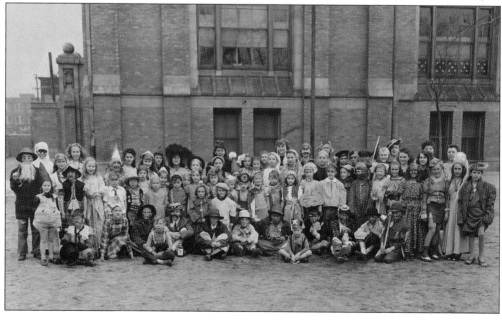

The James G. Blaine School Student Council's building and grounds committee takes a break during the 1945–1946 school year. The council, taking note of the end of World War II, took its duties seriously. It declared that its aim was "service to humanity." (Courtesy of Blaine School.)

A Blaine School student relaxes on a bus trip, possibly to Springfield. Blaine opened in 1893, months after the death of its namesake, James G. Blaine. A Republican speaker of the house from Maine, Blaine was famed for barely losing the 1884 presidential election in a nasty campaign. Grover Cleveland's supporters chanted, "Blaine, Blaine, James G. Blaine, the continental liar from the state of Maine." (Courtesy of Blaine School.)

Children are seen playing at Blaine School. The playground was the site of a low point for the school in 1983, when a 19-year-old was killed by a gang rival on the play lot 15 minutes after school ended. One sixth-grader described to a *Chicago Tribune* reporter how he hid in some bushes after shots rang out. (Courtesy of Blaine School.)

This photograph from the skinny-tie era shows students outside Blaine School, at 1420 West Grace Street. Now in its third century, Blaine was ranked the 13th-best school in the city by *Chicago* magazine in 2012. (Courtesy of Blaine School.)

Three

WORSHIPPING IN
LAKE VIEW

After 1880, churches were built in Lake View one after another. A number grew from congregations closer to downtown like seeds that floated north and sprouted in fertile soil.

One of the largest was St. Alphonsus, which was founded by German immigrants from St. Michael, in Lincoln Park, in 1882. The congregation grew so quickly—reaching more than 4,000—that it started work on a new church only seven years later. It was the biggest in Chicago, and the spire still towers over the neighborhood.

While many churches were German, there was a place for everybody: for the Irish, there was St. Andrew; for the group known as Kashubs, who had links to Germany and also Poland, there was St. Josaphat; for Germans who were Lutheran instead of Catholic, there was St. Luke.

The impact of Lake View's churches as cultural, social, and athletic centers was obvious. Parishes bustled with activity; at St. Alphonsus's Athenaeum, the second floor alone held five meeting rooms so groups could meet simultaneously.

Like so much else in Lake View, churches changed in the postwar years. The ranks of nuns and priests shriveled, as did congregations. St. Bonaventure came within a hair of closing. At St. Alphonsus, some of its spaces were converted to secular functions.

The churches did not stand idle. St. Alphonsus added Spanish-language Masses while also retaining a German Mass—the last one left in Chicago today. Religious schools provided an alternative to the beleaguered public school system. Some churches helped fight neighborhood decline through the Lake View Citizens Council.

Today, as the community evolves, the churches and their stately edifices remain, a reminder of the 1800s and the faith of the people who built Lake View.

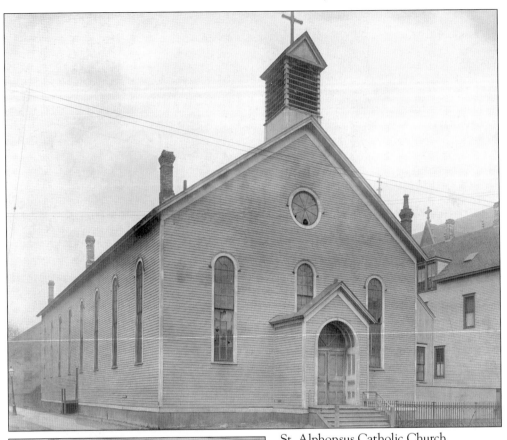

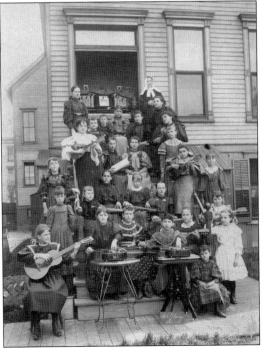

St. Alphonsus Catholic Church constructed its first building in 1882 at Oakdale and Southport Avenues after German Catholics, tired of walking south to St. Michael, pleaded with the Redemptorist Fathers to begin a mission. The church was named after Alphonsus Liguori, the founder of the Redemptorists, known for helping the poor. (Courtesy of the Redemptorist Fathers.)

Members of a St. Alphonsus School orchestra pose with their string instruments. St. Alphonsus built a new school in 1903, dedicating it with a parade of more than 1,000 men with brass bands and drum-and-fife corps, who were joined by hundreds of flag-waving students. (Courtesy of the Redemptorist Fathers.)

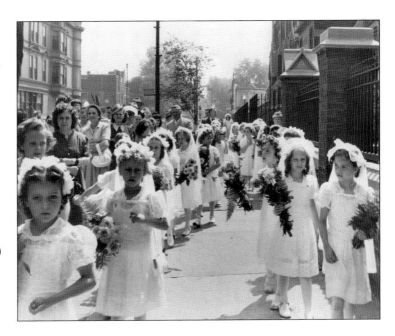

Girls march in a May procession in 1940 outside St. Alphonsus. The church bulged with children in its earliest days. The first pastor, Fr. Max Leimgruber, and two other priests performed 1,091 baptisms—and a startling 502 last rites—in just a couple of years in the 1880s. (Courtesy of the Redemptorist Fathers.)

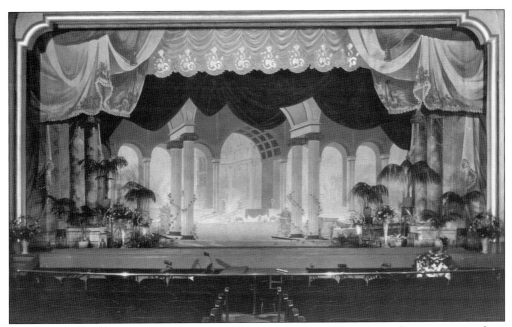

St. Alphonsus built a recreation center in 1911 that was "deemed by many to be pretentious, if not foolhardy," according to a church history. Called the Athenaeum, the center was huge. It held a gym, bowling alleys, meeting halls, and this 1,000-seat theater. Today, it is an independently operated venue for plays, but it is still owned by the church. (Courtesy of the Redemptorist Fathers.)

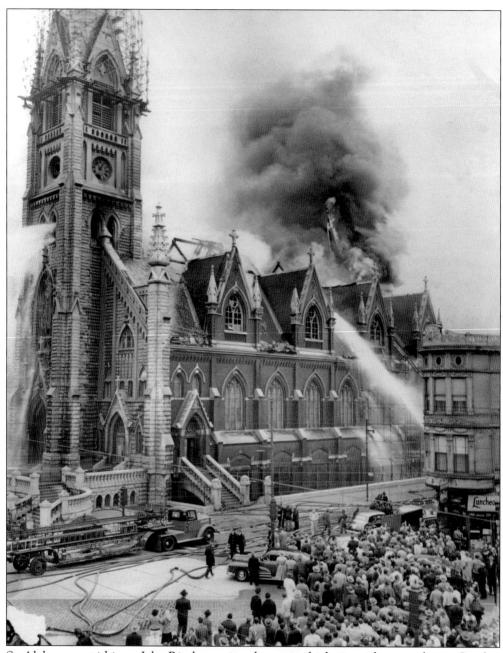

St. Alphonsus parishioner John Riegler was in a downtown high-rise with a coworker on October 23, 1950, when he saw smoke miles away. "Bill, that looks like my parish is on fire," he said. Riegler was right. As workmen replaced the roof, flames had broken out, leading to a blaze that hurt five firemen and ultimately cost $7.7 million of damage in today's dollars. (Courtesy of the Redemptorist Fathers.)

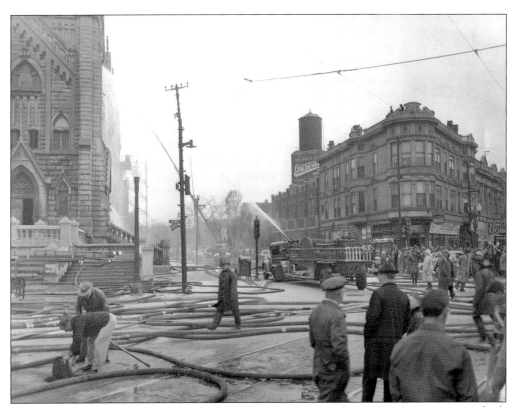

This view of the fire shows the flatiron-style building that now houses S&G Restaurant, which was founded in 1957. The disaster was severe for the church, but donations from both Christian and Jewish leaders in Lake View helped the church reopen two years later. (Courtesy of the Redemptorist Fathers.)

Nuns at St. Alphonsus get their first car in 1964. Standing from left to right are Sister Mary Edward, Rev. Thomas Monaghan, Bonnie Alford, Very Reverend Norman Muckerman, unidentified, Lorraine Artz, and Pauline Cabras. Some sisters had never been behind the wheel, so parishioner Joseph Artz took on the job of driving instructor. He is remembered as a man of great patience. (Courtesy of St. Alphonsus Catholic Church.)

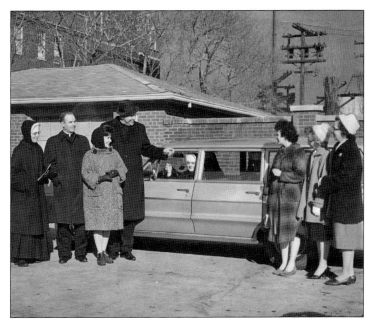

Two boys take part in a St. Alphonsus career day. At one time, St. Alphonsus ran not only an elementary school but also a commercial high school serving students through age 16. Today, the Alphonsus Academy and Center for the Arts goes through eighth grade. (Courtesy of the Redemptorist Fathers.)

Fran Gems played Mary Martin's character from *South Pacific* for a skit in the Mothers Club Frolic in 1961. The theme was "Where's Father Broker?" The hunt moved between Germany, Italy, and the Pacific before finding that the Rev. Bill Broker was right at St. Alphonsus, as seen in this photograph. The popular Mothers Club Frolics raised more than $8,000 yearly, Gems recalls. (Courtesy of Fran Gems.)

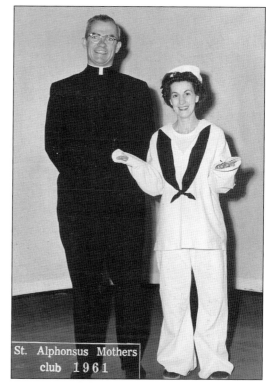

St. Alphonsus Mothers club 1961

St. Alphonsus took up the block bounded by Wellington, Southport, Oakdale, and Greenview Avenues. Moving clockwise around the block after the church are the Athenaeum, the Athenaeum's bowling alley (now Lakeview Pantry West), open space, the convent (now Marah's Place for disabled women), the school, and the rectory. (Courtesy of the Redemptorist Fathers.)

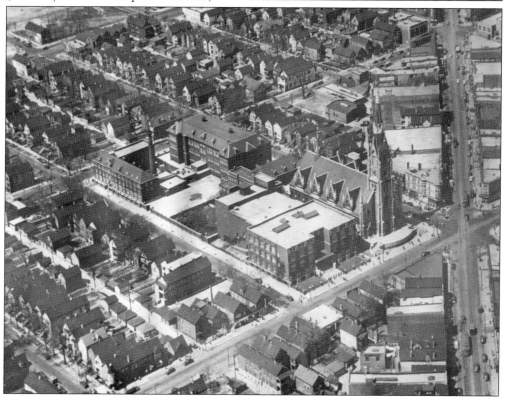

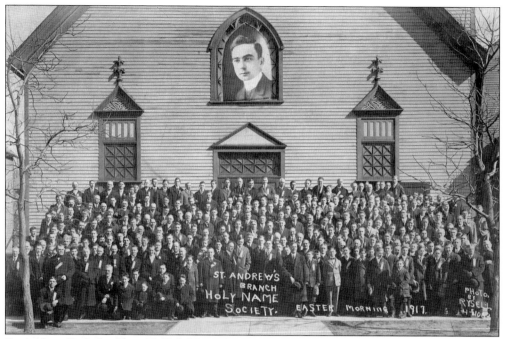

St. Andrew Catholic Church's Holy Name Society poses on Easter in 1917 in front of the original church. It should be noted that, strictly speaking, the original church was a tavern at Roscoe Street and Lincoln Avenue. Lore has it that the first Mass was celebrated above Westphal's Saloon in 1894 before a proper church could be built at Addison and Paulina Streets. (Courtesy of St. Andrew Catholic Church.)

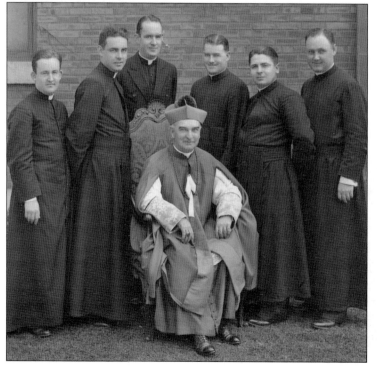

St. Andrew was led by the famed bishop Bernard Sheil (center), starting in 1935. Sheil, a baseball player who turned down a professional offer, founded the Catholic Youth Organization and took bold public stances, backing unions and denouncing Sen. Joe McCarthy. In 1966, at age 80, Sheil retired as pastor after what archbishop John Cody called a pleasant conversation. Sheil's version was different: "This is a removal," he said. (Courtesy of St. Andrew Catholic Church.)

Msgr. John Quinn is wheeled into a church celebration, apparently with a Far Eastern theme, in 1972. Note the man behind him, curiously in roller skates. When Quinn started as pastor in the 1960s as Sheil's replacement, St. Andrew was jam-packed with parishioners. Mass was celebrated starting at 5:00 a.m. and continued every hour on the hour, so 13 masses were held every Sunday. (Courtesy of St. Andrew Catholic Church.)

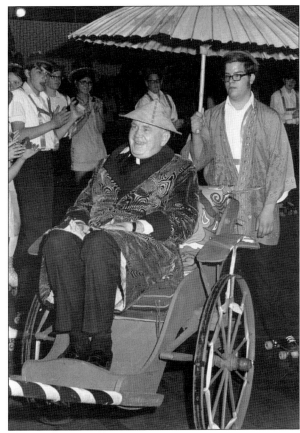

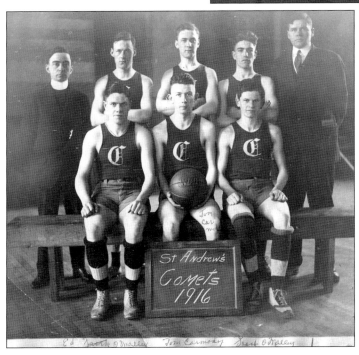

This photograph of the St. Andrew's Comets not only hints at the church's distinguished future in sports, the names written at the bottom, like O'Malley and Carmody, also suggest the parish's Irish roots. The first pastor, Rev. Andrew Croke, was a native of County Tipperary, and the church was founded by Catholics who would not have fit in at the German-speaking St. Alphonsus but were tired of trudging east to Mt. Carmel. (Courtesy of St. Andrew Catholic Church.)

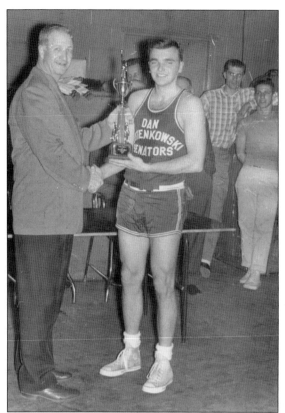

Larry Kurka (right) is awarded a trophy at St. Andrew. His jersey reads, "Dan Rostenkowski Senators." Rostenkowski later became a congressman and the powerful chairman of the Ways and Means Committee of the US House of Representatives, but he was once just an Illinois state senator. (Courtesy of St. Andrew Catholic Church.)

St. Andrew's athletic director for 35 years, Al Prislinger (far right), organized boxing tournaments and elaborate gym shows. The 3,000-seat St. Andrew gym has been a home for Catholic Youth Organization and Golden Gloves boxing, hosting such fighters as future Illinois attorney general Jim Ryan. In March 1975, a young Rod Blagojevich, future Illinois governor and eventual federal convict, sparred on Addison. (Courtesy of St. Andrew Catholic Church.)

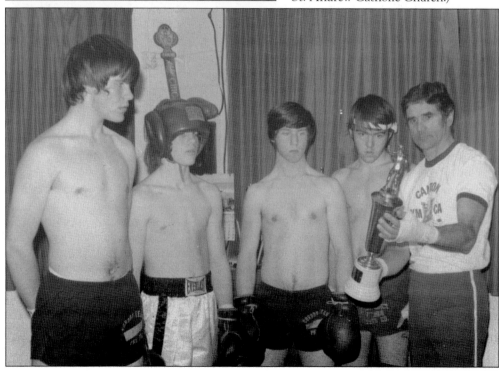

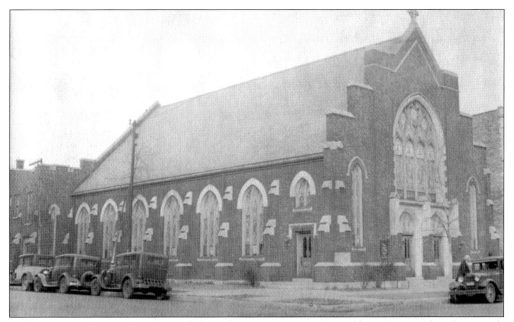

Holy Trinity Lutheran Church was dedicated in 1923 at 1218 West Addison Street. This photograph shows the Magnolia Avenue side of the church, which claims to be the oldest English-language Lutheran church in the city. It grew from the merger of the English Evangelical Lutheran Church of the Holy Trinity, which incorporated downtown in 1874, and St. Mark's Church, whose former site is now Wrigley Field. (Courtesy of Holy Trinity Lutheran Church.)

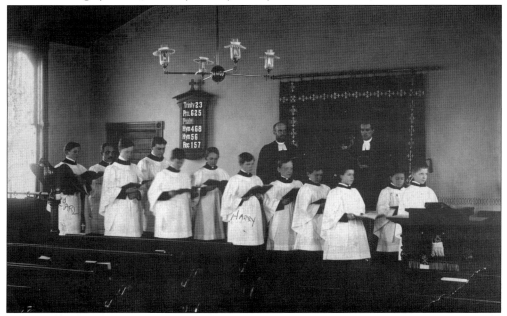

Rev. Zenan Corbet and another man stand with the choir at St. Mark's around 1900. St. Mark's was started in a frame chapel in 1890 at Clark and Addison Streets (now Wrigley Field) by Rev. W.A. Passavant, a prominent Lutheran. Passavant also founded Passavant Memorial Hospital (now part of Northwestern Memorial Hospital) and other Lutheran institutions. (Courtesy of Holy Trinity Lutheran Church.)

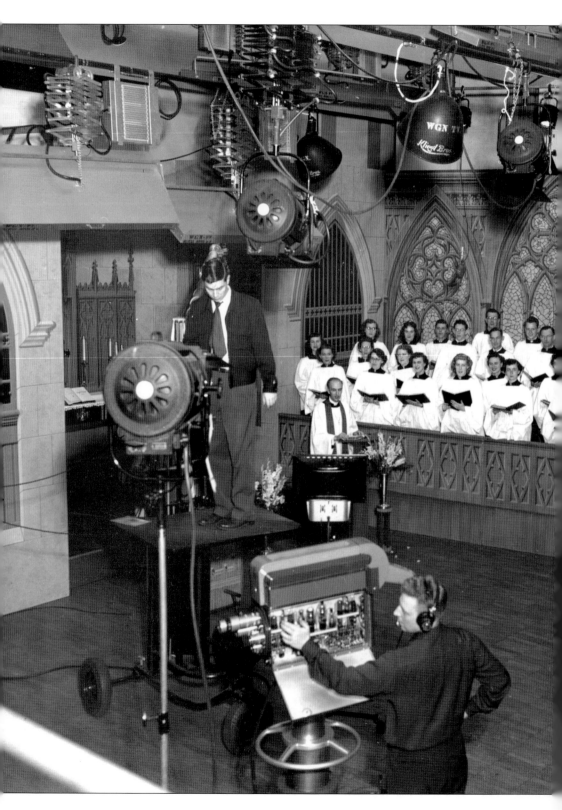

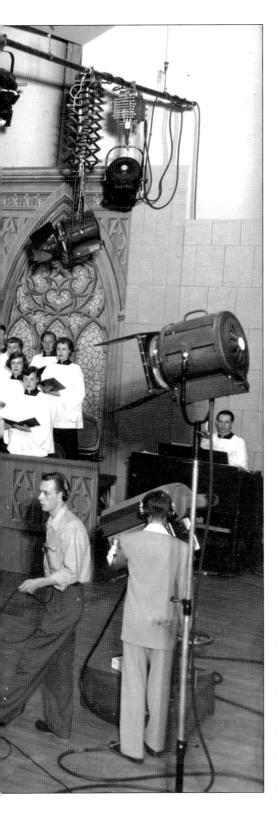

Holy Trinity, including Pastor Clyde Steele and organist Martin Argall, appeared on WGN-TV's *Faith of Our Fathers* program in 1952. Note the backdrop, replicating a church's stained glass and the "WGN" letters on one of the cameras up above. The congregation of that era was vigorous, supporting a Bible school, three Luther Leagues, a men's brotherhood, a women's missionary society, and an altar society, not to mention regular services. (Courtesy of Holy Trinity Lutheran Church.)

Holy Trinity bustles with activity in 1949. A *Tribune* columnist earlier in the decade complimented it for stretching its $7,552.53 budget. The church not only supported many groups and programs, it also managed to donate to missions, an orphanage, and Carthage College. (Courtesy of Holy Trinity Lutheran Church.)

Children are seen playing with vicar Ron Schlittler at Holy Trinity's vacation Bible school in 1958. (Courtesy of Holy Trinity Lutheran Church.)

This 1884 image shows St. Luke Lutheran, at 1500 West Belmont Avenue, when it had just been built amid the truck farms and pastures of Lake View. The church was constructed by members of St. James Lutheran, in Lincoln Park, who wanted a church farther north, closer to their homes. (Courtesy of St. Luke Lutheran Church.)

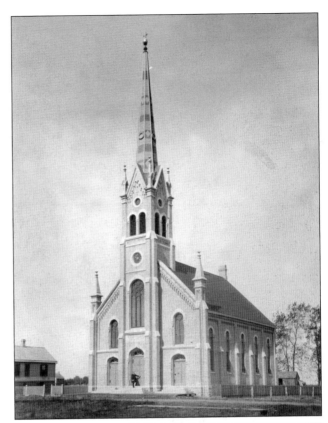

Teachers pose in 1895 at St. Luke Academy. In the early days of "Sankt Lucas Schule," a single pastor, J.E.A. Mueller, a native of Hanover, Germany, conducted classes in German and English. His influence was such that the *Chicago Tribune* once described a wedding as being located "at Mueller church." (Courtesy of St. Luke Lutheran Church.)

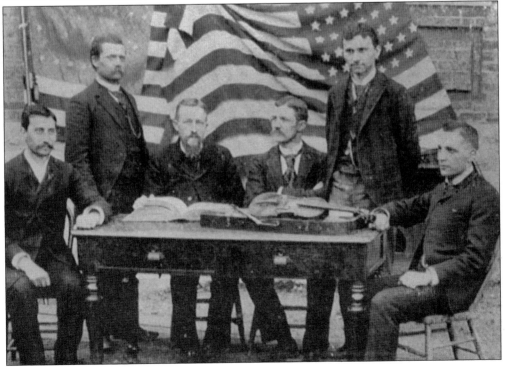

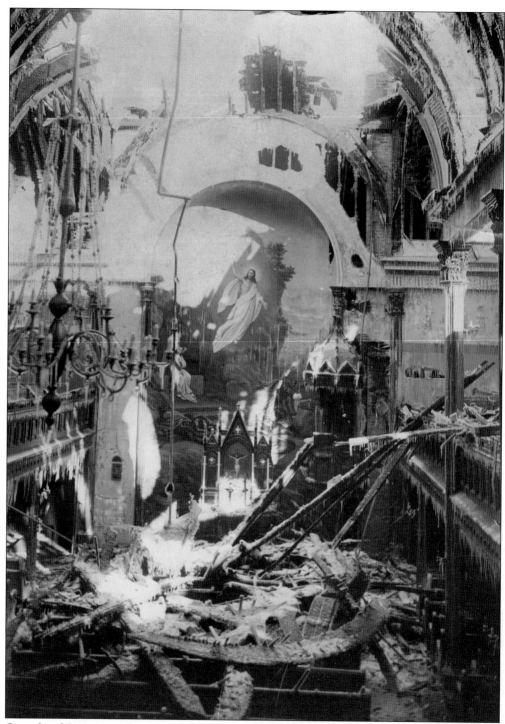

On a frigid January night in 1899, a fire devastated St. Luke. Pastor J.E.A. Mueller rushed to help the firemen but slipped on ice and fell a dozen steps, injuring himself, the *Chicago Tribune* stated. The church had insurance, but a mural worth $500, *The Ascension*, was lost. (Courtesy of St. Luke Lutheran Church.)

This image shows St. Luke in 1939, with Belmont Avenue running from left to right in front of it, intersected by Greenview Avenue. By that year, the church had nearly 2,500 members and, according to the *Chicago Tribune*, was the largest church in the Lutherans' Missouri synod. St. Luke eventually left that denomination. (Courtesy of St. Luke Lutheran Church.)

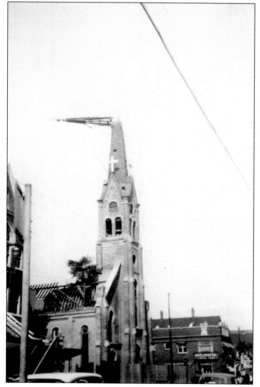

The congregation tore down its old church and broke ground in 1959 on an $800,000 building designed to seat 1,080. The altar was made of opalescent black granite, and the pews were made of African mahogany. (Courtesy of St. Luke Lutheran Church.)

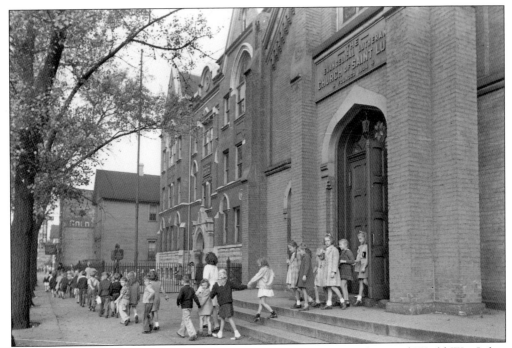

Children leave St. Luke in this undated photograph. It was not until around World War I that English became the primary language for teaching, reducing German to optional status. (Courtesy of St. Luke Lutheran Church.)

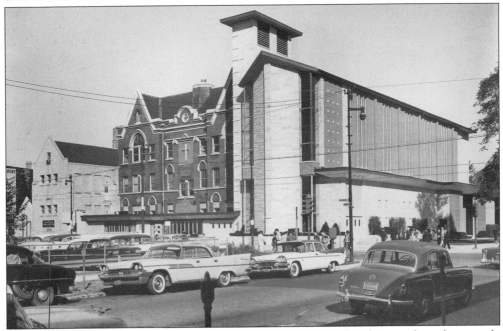

St. Luke, seen here in its new building in 1960, has been graced with a number of extremely dedicated teachers. One, a German native named Emil Garske, retired in 1955 after teaching for 52 years—without a single absence. And, the redoubtable Gertrude Doederlein was honored in 1988 after 65 years in the classroom. (Courtesy of St. Luke Lutheran Church.)

Four

LIVING IN LAKE VIEW

Old-timers remember when life in Lake View was centered on, well, Lake View. A father often walked to work—and maybe in a tie, even if he was a factory worker. The mother shopped at a local grocer or at one of the many specialty stores. At Roscoe Street and Lincoln Avenue, for example, there were half a dozen butcher shops within a couple of blocks. If a mother was really in a hurry, she could duck into a corner store on her own street.

As for the kids? They were nearby at a public or parochial school. In the summer, children found plenty of playmates without going far thanks to the large families of the era. Rick Giannoni was one of nine children, but he did not think the number was unusual; after all, one of his neighbors had 17. Air-conditioning and television were rare, so kids lived outdoors, swimming in the lake or playing sidewalk games like "bounce ball" or "ledge" or pitching pennies. With local shopping, working, and recreation, it was a neighborhood with no need for cars or even public transportation.

The rhythms of life also were different. Men started walking through the doors of Lawry's Tavern on Diversey Parkway around 8:00 a.m. The customers were building janitors who had awakened at 5:00 a.m. to tend to coal furnaces, so they were ready for a break. More workers came over at lunchtime. In the evening, men stopped by for a drink after work before heading home. After supper, they would come back to socialize. When a wife needed her husband, she just had to call the tavern. If she could not find him, there were plenty of relatives around to help, likely in the same three-flat. In Lake View, family was all around.

There are many classic Lake View stories; one of them happened in this gray stone at 1314 West Eddy Avenue. Lina and Paul Puder, both German natives, bought the building before World War II. Four generations lived there, and it stayed in the family until 1998. (Courtesy of Irene Borg.)

Lina Puder poses around 1940 in front of the family's building. Her granddaughter Irene Borg recalled that despite the German character of Lake View, residents stressed being Americans. Still, their heritage was all around; there were restaurants such as Schwaben Stube and Salzburger Hof on Lincoln Avenue, and her parents saw German movies at the Davis Theater. (Courtesy of Irene Borg.)

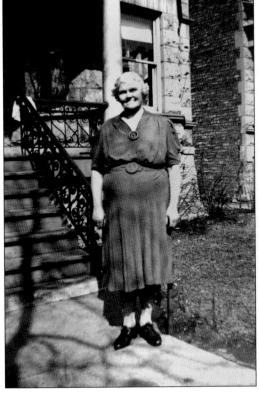

Six months after Pearl Harbor, Lina Puder earned a certificate for studying English and government. The German American families of Lake View were in an awkward position once war broke out. In Irene Borg's family, one of her grandfathers had fought for Germany in World War I, and then two of her uncles fought for the United States in World War II. (Courtesy of Irene Borg.)

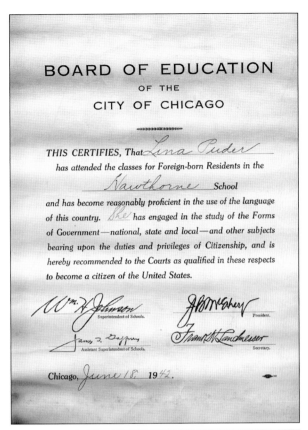

BOARD OF EDUCATION
OF THE
CITY OF CHICAGO

THIS CERTIFIES, That *Lina Puder*

has attended the classes for Foreign-born Residents in the

Hawthorne School

and has become reasonably proficient in the use of the language of this country. *She* has engaged in the study of the Forms of Government—national, state and local—and other subjects bearing upon the duties and privileges of Citizenship, and is hereby recommended to the Courts as qualified in these respects to become a citizen of the United States.

Wm. H. Johnson
Superintendent of Schools.

J. B. McCahey
President.

James F. Daphny
Assistant Superintendent of Schools.

Frank H. Landmesser
Secretary.

Chicago, *June 18*, 19*42*.

Lina Puder's son Paul married Pauline, seen here in 1978 at the family's West Eddy Avenue building. Paul worked at the old DuPont paint factory near Elston and Ashland Avenues, and Irene Borg remembers him going off to work in a hat and tie during the week and listening to opera on the weekends. (Courtesy of Irene Borg.)

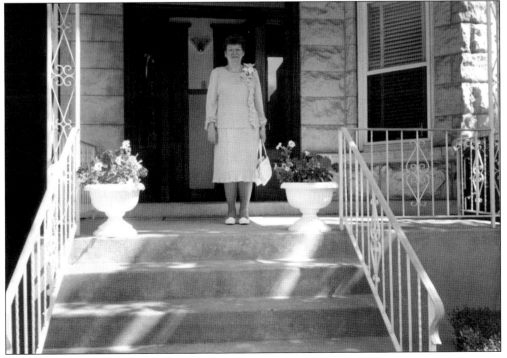

Irene Borg grew up in her family's gray stone, attending St. Luke Lutheran for grammar school, Luther North for high school, and then nursing school at another Lutheran institution, Augustana Hospital. (Courtesy of Irene Borg.)

Borg's daughter Paula (in the distance), the fourth generation to live in Lake View, enjoys the aftermath of a 1979 snowstorm. Irene Borg still attends St. Luke Church even though she has left the neighborhood. She lives near Foster Avenue and Pulaski Road, next to where St. Luke has put its cemetery, which she intends to be her final resting place. (Courtesy of Irene Borg.)

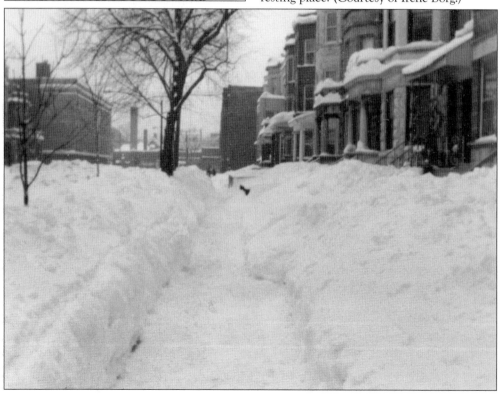

Frank (left) and John Riegler mark their first communion at St. Alphonsus in 1931. Born in 1922, John has lived in Lake View since 1927 and in the same building on the 1000 block of West George Street since about 1940. Adding to the continuity, his sister Veronica Frohnauer still lives upstairs. (Courtesy of John Riegler.)

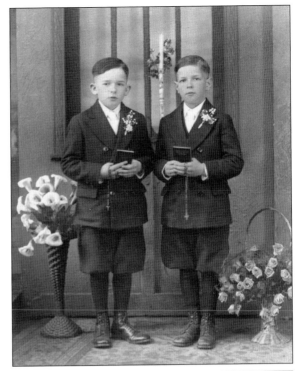

Many decades later, Frank (left) and John Riegler show off their perch caught at Belmont Harbor. Growing up, John remembers going to the lakefront three times a day: in the morning to fish, in the afternoon to swim, and at night to get worms to go fishing the next day. (Courtesy of John Riegler.)

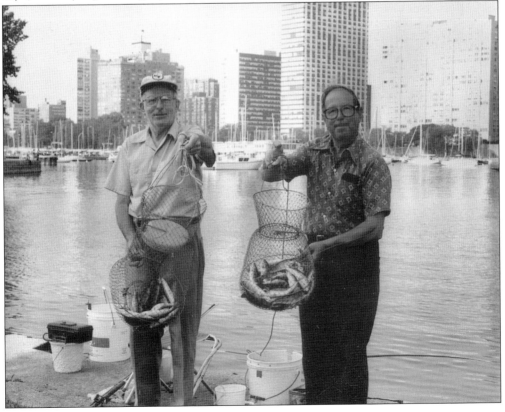

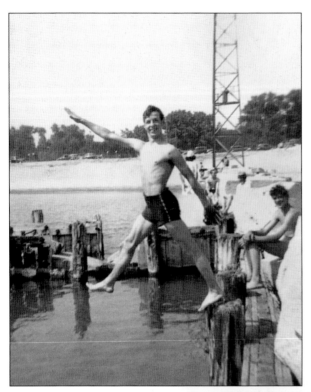

John Riegler takes a confident step into Diversey Harbor. Forced to work at age 16, he got a job as a Western Union telegram boy. He went on to be the engineer at St. Alphonsus Church for 33 years. (Courtesy of John Riegler.)

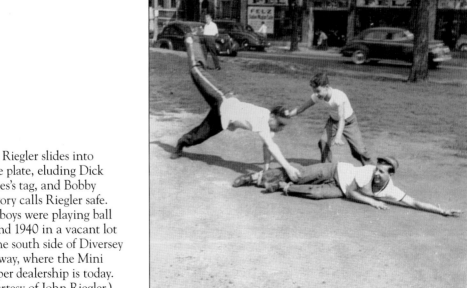

John Riegler slides into home plate, eluding Dick Mertes's tag, and Bobby Gregory calls Riegler safe. The boys were playing ball around 1940 in a vacant lot on the south side of Diversey Parkway, where the Mini Cooper dealership is today. (Courtesy of John Riegler.)

John Riegler (center, with tin cup) hangs out with his neighborhood gang in the basement of the building where he still lives today. The gang, about 10 guys who socialized together, proved to be a hardy bunch, as half of them were still alive in 2013. (Courtesy of John Riegler.)

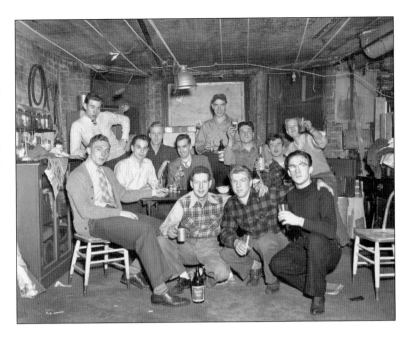

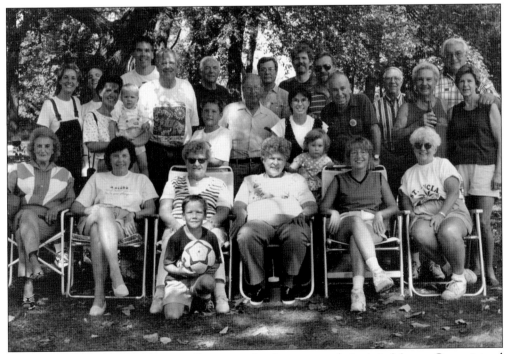

John Riegler's neighborhood gang still gets together for an annual picnic in Morton Grove, joined by wives, children, and grandchildren. Here, at the 1998 picnic, Riegler is standing in the center in a light dress shirt and wearing glasses. His wife, Lorraine, is in front with a striped shirt and dark glasses. (Courtesy of John Riegler.)

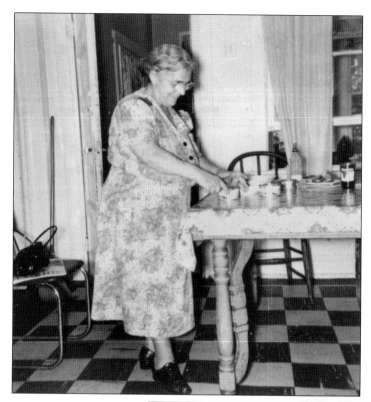

Jerry Gems's grandmother Benedetta DiBenedetto works in her kitchen at 1131 West Drummond Place in 1948. Many people wanted to move out of the neighborhood, says Jerry, but a lot of his relatives bucked the trend. DiBenedetto's son Frank DiBenedetto still lives nearby, as do others. (Courtesy of Jerry Gems.)

Jerry Gems (left) and his brother John stand in front of their home at 2657 North Racine Avenue in 1953. They were German on their father's side and Italian on their mother's, reflecting the hodgepodge neighborhood. While much of Lake View was heavily German, south of Diversey there were Italians who had moved up from the Cabrini-Green area, as well as Greeks, Puerto Ricans, Irish, Japanese, and African Americans, Jerry Gems recalls. (Courtesy of Jerry Gems.)

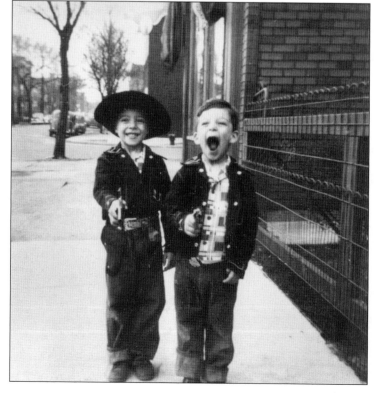

Jerry Gems and his friend Leo Puzzo (pictured) played on a Methodist church basketball team. In the dense neighborhoods that were typical of the 1960s, local sports teams abounded, organized around churches, schools, and parks. Gems became a North Central College professor and wrote a book called *Windy City Wars* about immigrants and sports in Chicago. (Courtesy of Jerry Gems.)

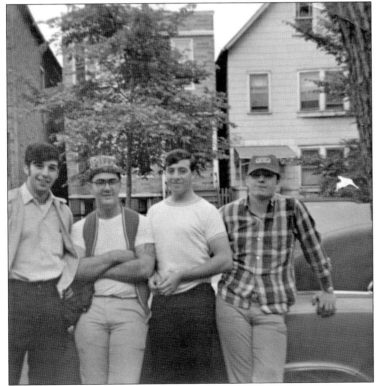

Lake View got tough in the 1960s, and the guys looked it, too. Seen here from left to right are John Gems, Leo Puzzo, Jerry Gems, and Tom Hohenstein. Fights with rivals from Webster Avenue grew worse, Jerry recalls, so he and Puzzo volunteered for the Marines. "If you go in the Marines, you're going to Vietnam" was his logic. "At least you get paid for getting shot at." Thankfully, they all made it back. (Courtesy of Jerry Gems.)

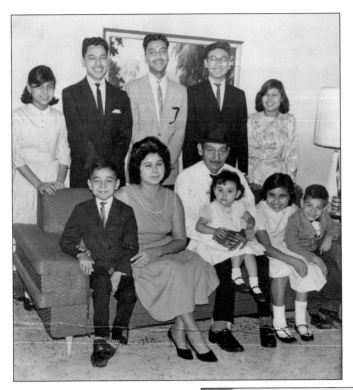

Eugenio and Anita Alcozer moved to Oakdale and Sheffield Avenues in 1964. They had been migrant workers, but they settled on the West Side and then moved to a two-bedroom apartment in Lake View. Their five boys—Tony, Jesse, Ralph, Eugenio Jr., and Robert—lived in one bedroom, while their four girls—Grace, Francesca, Olga, and Gloria—lived in the other. The parents slept in the dining room. (Courtesy of Francesca and Grace Alcozer.)

In 1967, the Alcozer family moved to this house on the 3000 block of North Clifton Avenue, where Francesca and Grace still live. Gangs troubled the neighborhood then, Francesca remembered, but they left most people alone as long as they were not part of an enemy gang. Times have changed, and now she gets $500,000 offers to sell the house for a teardown. (Courtesy of Francesca and Grace Alcozer.)

The Alcozers weathered the famous snowstorm of 1967. In the foreground is the 900 block of Oakdale Avenue, looking west. In the background is a building at the northwest corner of Oakdale and Sheffield Avenues. It later housed Pops for Champagne and is now the home of Kirkwood Bar & Grill. (Courtesy of Francesca and Grace Alcozer.)

Jesse Alcozer, coming home from Marine training in 1968, surprises his father. The Alcozers have had a remarkable career of service to their country. Eugenio Sr. served in the Army, and four of his sons were in each of the four service branches. One of them, Jesse, survived Vietnam with seven wounds. Jesse's son Christopher fought in Iraq and was killed there in 2005. (Courtesy of Francesca and Grace Alcozer.)

John Haderlein, a German immigrant, was a saloon keeper and alderman of the 45th Ward from 1910 to 1922. He was also the first of four generations to be in real estate, making the Haderlein name familiar for a century of Lake View residents. (Courtesy of Jerry Haderlein.)

John N. Haderlein, the alderman's son, was also politically active. He is seen here (center) celebrating Harry Truman's 1949 inauguration with 43rd Ward alderman Paddy Bauler (left), 45th Ward committeeman Charles Weber (second from left), and county party chief Jacob Arvey (right). Haderlein was nominated for the US House of Representatives but gave it up to be Chicago's postmaster. Bauler, of course, is known for saying, "Chicago ain't ready for reform." (Courtesy of Jerry Haderlein.)

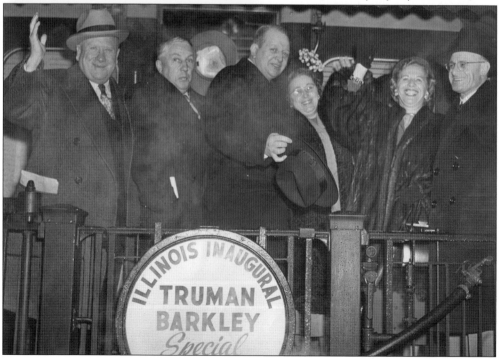

John N. Haderlein presided over a German American singing festival in 1949, an event so large it was held at Chicago Stadium. He was postmaster at the time, a job often held in Chicago by German Americans. (Courtesy of Jerry Haderlein.)

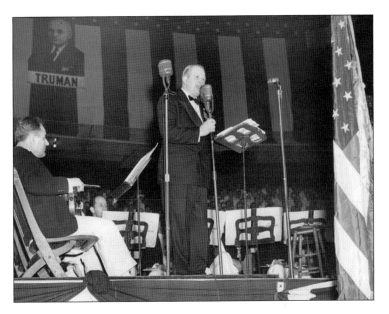

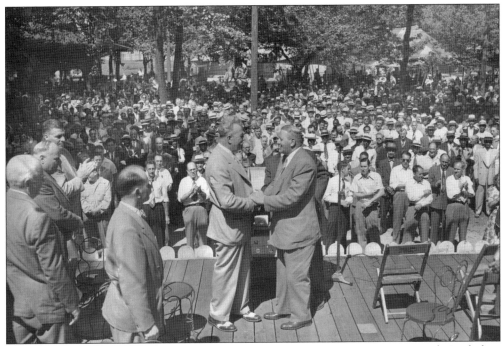

John N. Haderlein (right) greets Everett Dirksen at German Day at Riverview Park. Haderlein resigned his postmaster position in 1952 after being charged with bribery; however, he wound up being acquitted and continued his successful real estate business in Lake View. "He was a good servant of the neighborhood," his grandson Jerry recalls, and he was eventually offered another political post. (Courtesy of Jerry Haderlein.)

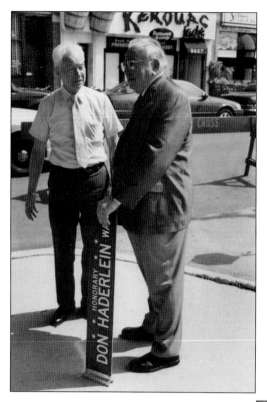

Donald Haderlein (right), of the third generation of Haderleins, holds the street sign put up in his honor in 2001 on the 3400 block of Paulina Avenue near the family real estate business. With him is his cousin John F. Haderlein. Donald decided to keep the business in Lake View even during the neighborhood's days of decline. "He wanted to hang in there and fight to bring it back," his son Jerry said. (Courtesy of Jerry Haderlein.)

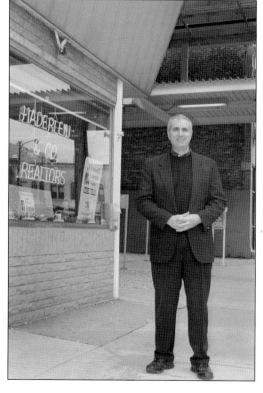

Jerry Haderlein stands at the Paulina Avenue real estate office. A family quarrel in the early 1900s split the Haderlein business, so there is also a Haderlein real estate office run by Jerry's cousins Mike, Bob, and Jim at 3049 North Ashland Avenue. (Courtesy of Jerry Haderlein.)

From left to right, Tony Kaleth, his brother Jim Reibel, cousin Rosemary Mattern Kramp, and cousin Richard Reibel take a break at 1822 West Grace Street in 1951. Tony lived there for two years in a room facing the "L" tracks. "It took about two days to get used to it, and then, for the most part, it was silent to me," he says. (Courtesy of Tony Kaleth.)

Emmet Skroch (left) camps out in his neighbor Jim Heide's yard in the 1950s. Skroch's parents bought their two-flat at 2330 North Wayne Avenue for $13,000 in 1943. The family sold it in 2000 for $330,000 only to see it torn down so a house could be built. (Courtesy of Emmet Skroch.)

Young men play football in Lincoln Park near Diversey Parkway in the 1960s. The uniforms consisted of whatever could be found, and helmets were optional. (Courtesy of Jerry Gems.)

A bowling team from Holy Trinity Lutheran Church, on Addison Street, poses for a team photograph. (Courtesy of Holy Trinity Lutheran Church.)

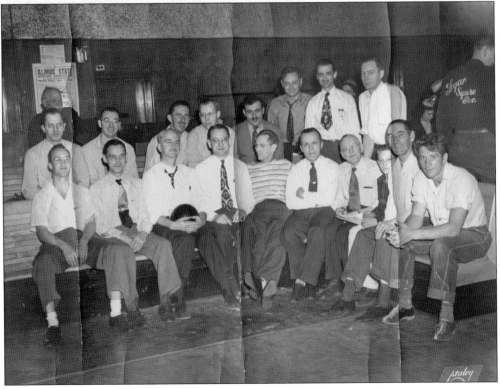

The Kle-Vir Korner tavern was on Diversey Parkway near Southport Avenue, recalls Frank DiBenedetto. His wife, Marie DiBenedetto, is seated second from the left in the first row in this c. 1950 photograph. (Courtesy of Frank DiBenedetto.)

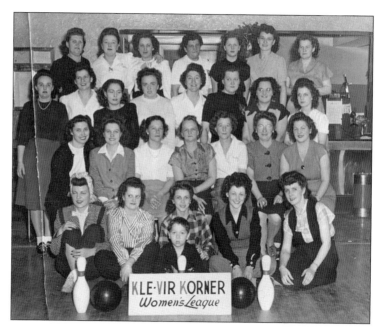

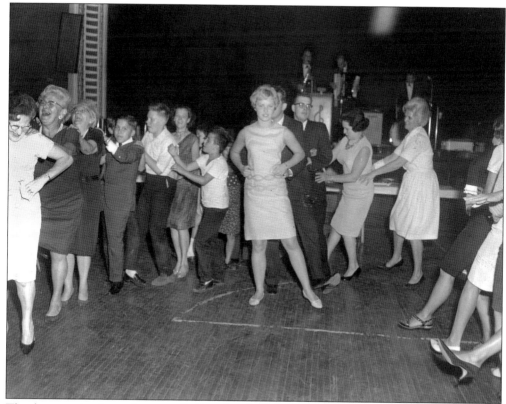

The dance train chugs along at a St. Josaphat Catholic Church event. (Courtesy of St. Josaphat Catholic Church.)

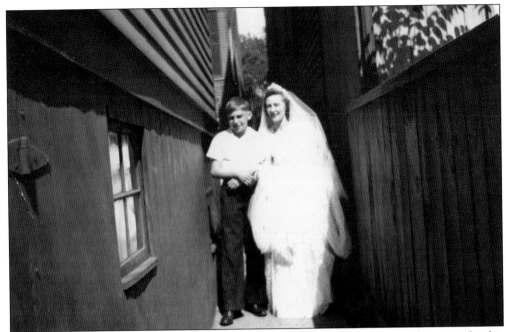

Only in Chicago does a bride squeeze through a gangway. Florence Slawikowski pauses for this photograph on her wedding day at 2552 North Southport Avenue. There were seven Slawikowski sisters total, and they grew up in a two-bedroom apartment. Florence Slawikowski Mack is now in her 90s and living in the northern suburbs. (Courtesy of Jim Pokryfke.)

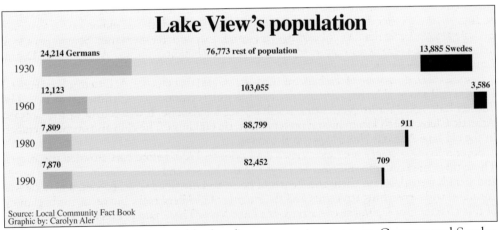

Lake View's population

	Germans	rest of population	Swedes
1930	24,214 Germans	76,773 rest of population	13,885 Swedes
1960	12,123	103,055	3,586
1980	7,809	88,799	911
1990	7,870	82,452	709

Source: Local Community Fact Book
Graphic by: Carolyn Aler

The population of two of the neighborhood's most prominent groups, Germans and Swedes, changed over the years. After World War II, their numbers declined, with the Hispanic population surging to 19 percent of the neighborhood by 1980. Overall, Lake View's foreign-born population saw a sharp decline across the decades, dropping from 29 percent in 1930 to 15 percent in 1990. Note that the numbers of Germans and Swedes represent not just natives of those countries, but also descendants. Changing definitions of ancestry, as well as missing data, make comparisons over decades difficult, but this chart gives a general sense of population patterns.

Five

Gone but Not Forgotten in Lake View

Memories are sometimes the sweetest when they recall what is lost, such as the sound of the train chugging up Lakewood Avenue as boys ride it to Wrigley Field, the taste of a sandwich at Kuhn's Deli, or maybe the smell of the Wonder Bread factory on Diversey Parkway. Some of Lake View's treasured establishments are hard to recall because they were torn down, like the timbered halls of Zum Deutschen Eck and the Peerless Confection factory. But, the neighborhood is fortunate because a remarkable number of buildings still stand, only with different uses. Sometimes a look up at the cornice reveals a structure's former owner. The building housing Always There Dental Care still has a Masonic symbol at the top.

In some cases, the nature of the building has not changed that much. P.A. Birren & Sons Funeral Home is still a funeral home, and Lawry's Tavern is still a tavern, only with different owners. The Turners hall, noted for its gymnastics, is still a place for exercise. It was bought by the Chicago Athletic Clubs, which locate in and preserve historic buildings. The club also opened a branch in the old Jane Addams Hull House on Broadway.

Beyond living memory are Lake View's days prior to 1900, before cars crowded the streets. Those times are harder to imagine, and fewer of the houses and stores remain. Even the smells and sounds were different then; the stench of horse manure filled Chicago's air, and noise was constant, with screeching streetcars and the ringing of peddlers' bells. Images at the beginning of this chapter give a glimpse of carriage-era Lake View. These rare photographs cannot fully capture those times, but they suggest a feeling.

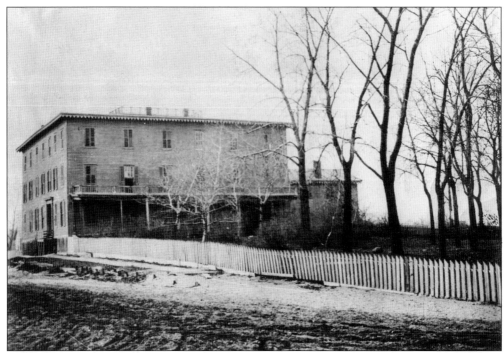

The Lake View House opened in 1854 near Grace Street and the lakefront, attracting affluent Chicagoans who wanted to escape the summer heat and cholera. This photograph was taken in the 1880s. (Courtesy of the Chicago Public Library, Sulzer Regional Library, RLVCC 1.33.)

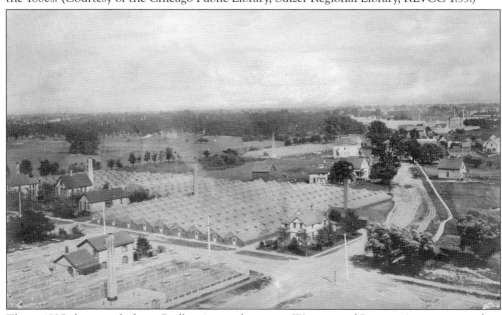

This c. 1925 photograph shows Budlong's greenhouses, at Western and Berwyn Avenues, according to the *Lake View Saga*. The Budlong operation was started by Lyman Budlong, a settler from Rhode Island. He grew vegetables, including cucumbers, and ultimately built what the *Chicago Tribune* called the largest pickle farm in the world. (Courtesy of the Chicago Public Library, Sulzer Regional Library, RLVCC 1.3.)

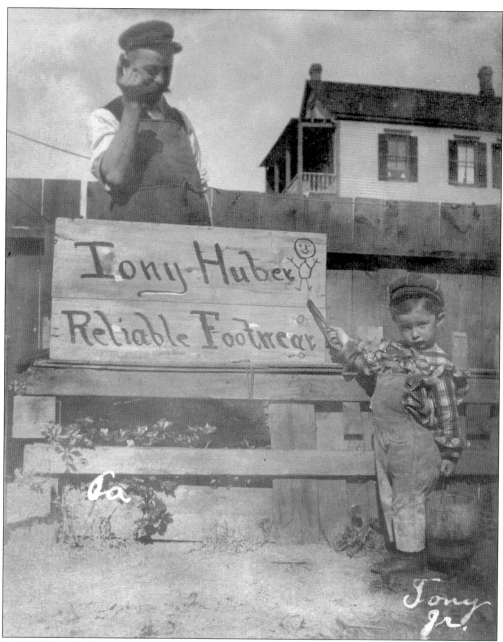

Shoe seller Tony Huber advertises his business with his son Tony Jr. Tony Huber Boots & Shoes operated at what is now 3118 North Lincoln Avenue, between Barry and Belmont Avenues. The store was just north of where Chicago's Pizza is today. (Courtesy of the Redemptorist Fathers.)

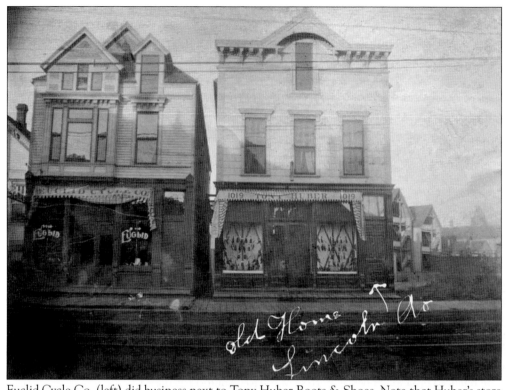

Euclid Cycle Co. (left) did business next to Tony Huber Boots & Shoes. Note that Huber's store was located at 1019 Lincoln Avenue, a number in the city's old address system. Chicago changed to its current system in 1909. (Courtesy of the Redemptorist Fathers.)

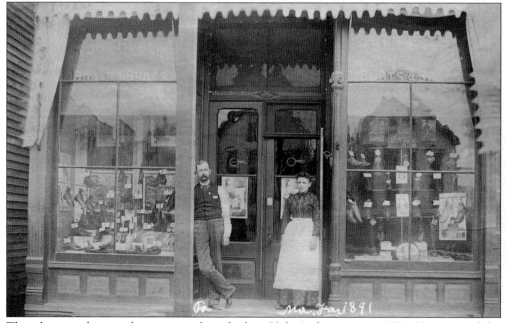

This photograph gives the viewer a closer look at Huber's shoe store in 1891. (Courtesy of the Redemptorist Fathers.)

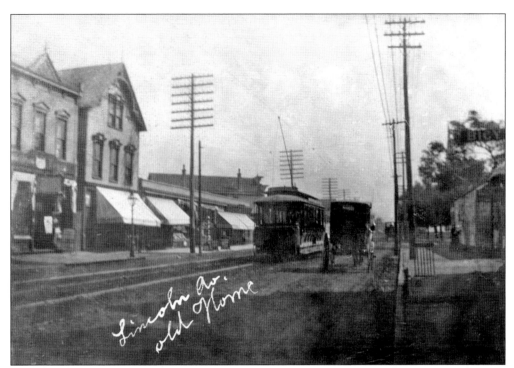

Lincoln Avenue is seen here after the advent of electric streetcars but before horse-drawn carriages were replaced by automobiles. (Courtesy of the Redemptorist Fathers.)

Residents pause for a photograph at 1549 Diversey Parkway. This house still stands just east of Ashland Avenue, and the lot next to it remains open. (Courtesy of the Redemptorist Fathers.)

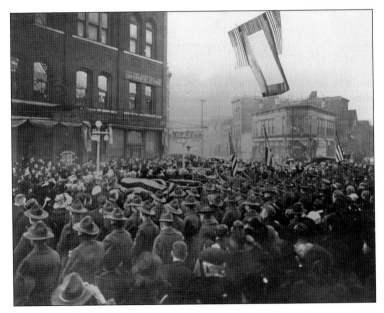

Soldiers and civilians come together on Racine Avenue where it meets Diversey Parkway and Lincoln Avenue, perhaps during World War I. The photograph looks north on Racine Avenue. On the left is a Freemasons building that was dedicated in 1886. Lake View Lodge 774 moved in 1931, but it continues today as Skokie Composite Lodge 774, on Lincoln Avenue in Skokie. (Courtesy of Frank DiBenedetto.)

Nearly a century later, the Freemasons building survives, and a Masonic symbol is still on its cornice, although it is not seen in this photograph. Neighbor Frank DiBenedetto remembers that it became a music hall for a time. It is now notable for its statue of a dentist wielding a giant toothbrush and advertising Always There Dental Care. The building on the north side of the intersection has been torn down; the site is now a strip of pavement in front of Gino's East. (Photograph by author.)

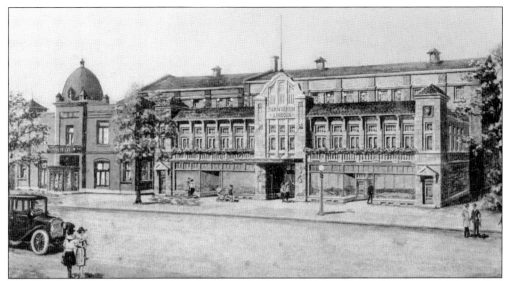

The Lincoln Turners hall, at 1019 West Diversey Parkway, was built in 1923 and was a center for German-Americans for decades. The Turners club was known for its gymnastics and swimming, but it was part of a larger political and cultural movement dating to 19th-century Germany. Immigrants brought the clubs to America, and by 1890 Chicago had 34 Turnverein, as they were called in German. (Courtesy of the Lincoln Turners.)

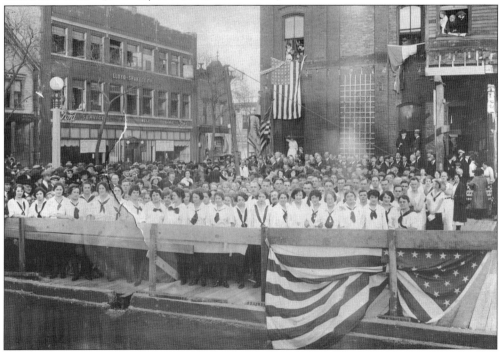

During the world wars, German Americans struggled to prove their patriotism; perhaps this event alongside the Lincoln Turners hall was such an attempt. In 1938, the hall saw what the *Chicago Tribune* called a "near riot" when antifascists battled a pro-Nazi group rallying inside. The same year, the Illinois Turners disavowed fascist connections, and the national organization changed its name to American Turners. (Courtesy of the Lincoln Turners.)

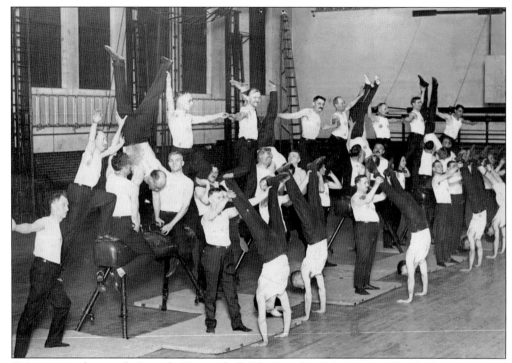

Gymnasts perform at the Lincoln Turners hall. The founder of the Turners, Friedrich Jahn, helped pioneer gymnastics with the invention of equipment like the balance beam and the parallel bars. At the Lincoln club, one of the greatest gymnasts was Meta Elste, a German-born Chicagoan who helped the US Olympic team earn a bronze medal at the 1948 Olympics. (Courtesy of the Lincoln Turners.)

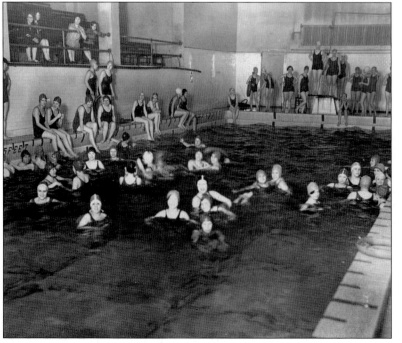

Many Lake View old-timers fondly remember the pool at the Turners club. Besides the Lincoln Turners hall, Lake View also had the Social Turners hall, at Belmont and Paulina Avenues. (Courtesy of the Lincoln Turners.)

This magnificent domed section of the Lincoln Turners hall once stood on the east side of the complex. (Courtesy of the Lincoln Turners.)

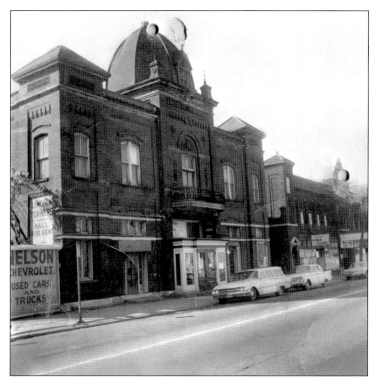

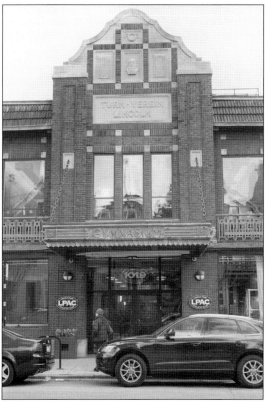

The hall is seen here as it looks today. The Lincoln Turners sold it to the Chicago Athletic Clubs in 1998 on the promise the building would not be torn down (the domed section was already demolished). A bust of Jahn and "Turn-Verein" can still be seen carved in stone near the building's top. The Lincoln Turners, though now homeless, are still active. (Courtesy of the Lincoln Turners.)

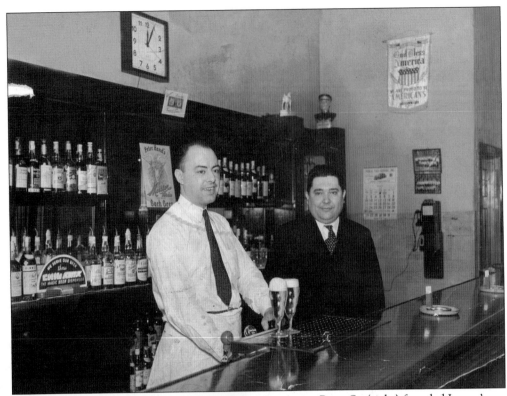

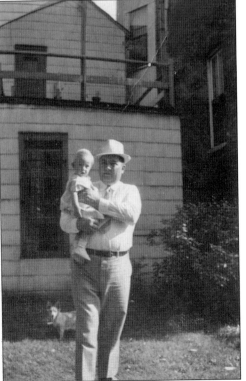

Lawrence Price Sr. (right) founded Lawry's Tavern shortly after Prohibition was lifted in 1933. It was originally in the Lincoln Turners hall, at 1019 West Diversey Parkway, but moved across the street to 1028 West Diversey in 1937. Price, and then his son Lawrence Price Jr., operated it until 2007, when it was sold to Chris Latchford and Pat Berger and became Paddy Long's. (Courtesy of Lawrence Price Jr.)

Lawrence Price Sr. holds his son Lawrence Jr. behind the tavern, where they also lived, in 1939. Business was steady throughout the day, Price Jr. recalls, with midnight-shift workers coming in at breakfast time, joined by early-rising janitors. Then there was a lunch rush, followed by more men stopping by in the evening. (Courtesy of Lawrence Price Jr.)

Lawrence Price Jr. poses in 1945. One of the keys to Lawry's survival for so long was "gimmicks," he says. The bar had television early, as this photograph shows, and then it installed a 100-inch projection television. At one point, Lawry's boasted an antenna that could pick up Bears games from South Bend, Indiana, when they were blacked out from viewing in Chicago. (Courtesy of Lawrence Price Jr.)

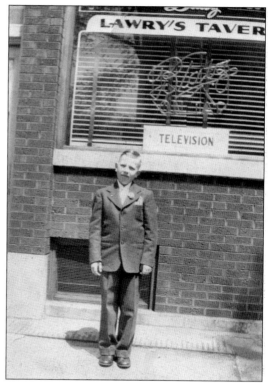

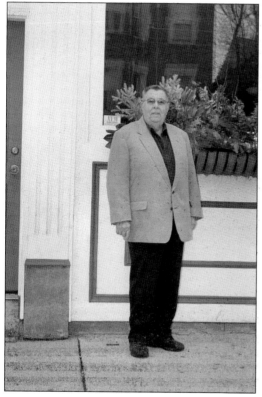

Lawrence Price Jr., posing outside his old tavern, has lived in Lake View his entire life, spending the last four-plus decades with his wife, Jackie, two streets north of the bar. The neighborhood changed, but he never left. "Where was I going to go? I had three children. I had a nice house," he said. "I paid more for my last car than I did for this house." (Photograph by author.)

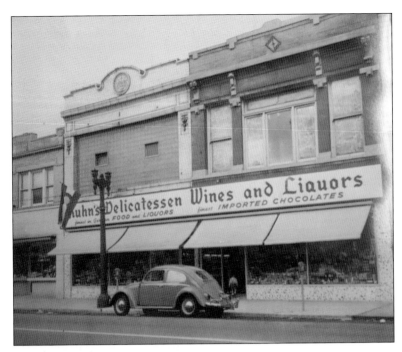

Kuhn's Deli, founded in 1929, operated for many decades at 3053 North Lincoln Avenue. As many Lake View residents did, the deli moved to the northern suburbs. It still sells blood sausage, goose liver, and potato pancakes at Golf and Elmhurst Roads in Des Plaines. (Courtesy of Kuhn's Deli.)

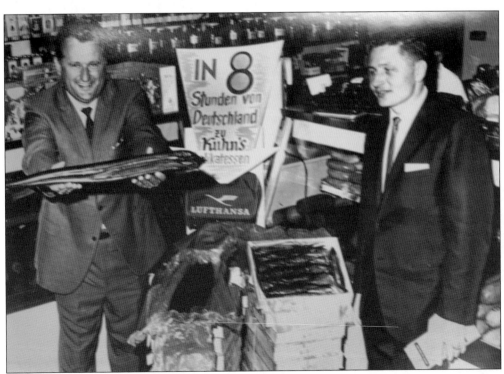

Frank Wagner, who ran Kuhn's with his wife, Marion, shows off one of his offerings. According to family history, the deli had a deal with Lufthansa Airlines to fly in fresh fish from Germany. The surviving suburban Kuhn's is still in the Wagner family. (Courtesy of Kuhn's Deli.)

Many Lake View residents remember Merz Apothecary, which operated on the 2900 block of North Lincoln Avenue from 1875 until the 1980s. Third-generation owner Ralph Merz sold it in 1972 to Abdul Qaiyum, who is seen here on the left with a business associate from Germany. (Courtesy of Merz Apothecary.)

A sign announces the apothecary will no longer sell narcotics because of robberies. Rising crime helped prompt Qaiyum to move Merz in 1982 to the German stronghold of Lincoln Square. Qaiyum, who was born in India, married a German American woman, and their son Anthony works in the shop today. He studied in Vienna and still speaks German to customers. (Courtesy of Merz Apothecary.)

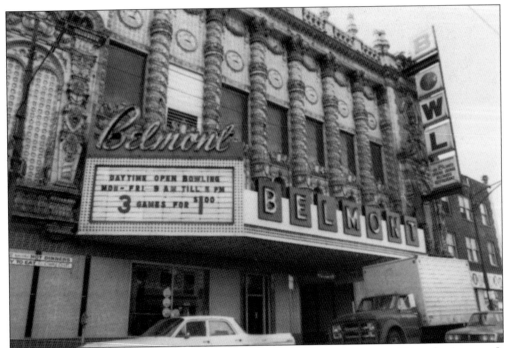

The Belmont Theater opened in 1925 on its namesake street, just west of Lincoln Avenue. It boasted more than 3,200 seats and became part of the Balaban & Katz chain in 1930, according to Cinema Treasures. The theater became a bowling alley, as seen here, in the 1960s. Today, it is the Cinema Lofts condominium building. (Courtesy of the Illinois Historic Preservation Agency.)

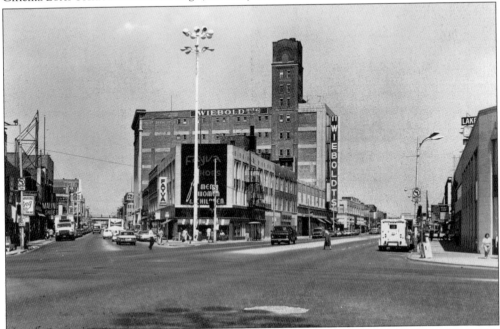

A look north on Lincoln Avenue (left) and Ashland Avenue (right) in 1985 shows Wieboldt's department store in its waning days. The Lake View Trust & Savings Bank is on the far right. (Courtesy of the Chicago Public Library, Sulzer Regional Library, RWK 1.13.)

One could get a hot dog and a Coca-Cola for 50¢ in the 1970s at the Jupiter five-and-dime store, at 3141 North Lincoln Avenue. The Jupiter stores, now defunct, were discount outlets for Kresge stores. Both were sold by their owner, Kmart, in 1987. (Courtesy of Ray and Kristine Hallowell.)

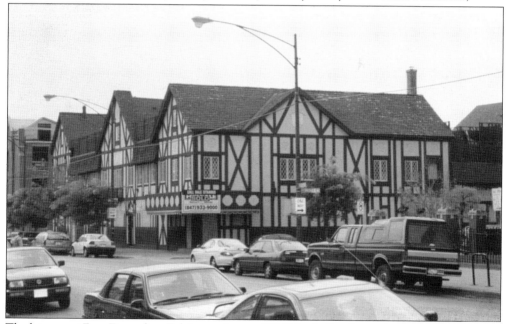

The late, great Zum Deutschen Eck is seen here at 2924 North Southport Avenue after it was sold in 2000. One of the last of the old German restaurants, the "German Corner" was started in 1956 by Al Wirth Sr. His son estimated that the restaurant handled more than 3,000 weddings and 1,100 funerals over the years, according to the *Chicago Tribune*. It was so beloved that a plaque now marks its former site. (Courtesy of Mark Susina.)

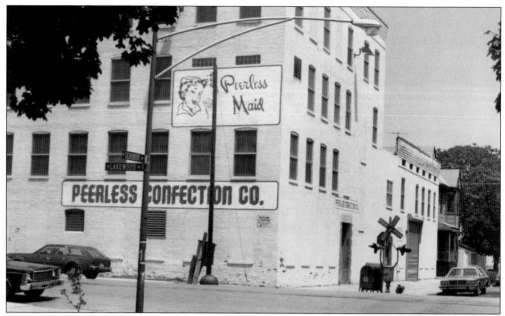

One of the factories that lined Lakewood Avenue was Peerless Confection. The company, founded in 1914, closed its factory in 2007, one of the many industrial plants the community has lost. As recently as 1995, about 10,000 people worked in the candy industry in Cook County. That number dwindled as many companies, like Peerless, suffered from sugar prices artificially kept high by federal price supports. (Courtesy of Kathleen Picken.)

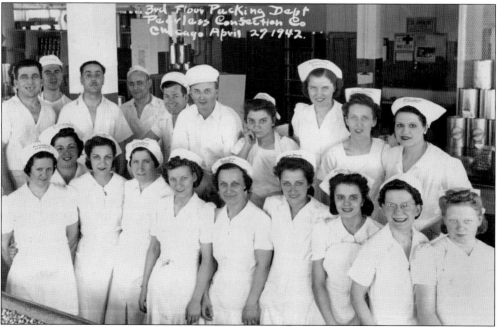

Peerless workers from the third-floor packing department pose for a photograph in 1942. Many of the workers, like the founders, were German. Women typically worked in packing, such as running the machines that wrapped the candies in cellophane for example. Men often worked in manufacturing, doing tasks like lifting 125-pound kettles of liquid sugar. (Courtesy of Kathleen Picken.)

Peerless made Starlight Kisses, Butterscotch Buttons, and other candies in what was a three-generation family business. Kathleen Picken, a grandchild of one of the founders, and CEO Russ Lyman wrote a letter upon closing that stated they did not want to move overseas and "betray our tradition of quality." Instead, they shut down while they could still offer what they considered a generous severance. (Courtesy of Kathleen Picken.)

Houses rise in 2013 on the site of the Peerless factory, which stretched from Schubert Avenue to Diversey Parkway. Before the plant closed, train cars full of sugar ran along the tracks on Lakewood Avenue. Spectators watched as the train wound through the Lakeshore Athletic Club's lot and past a gate (which opened for it on Tuesdays) at Wrightwood Avenue. (Courtesy of Kathleen Picken.)

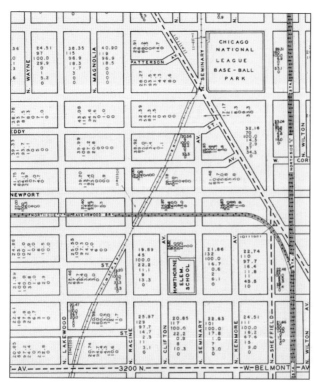

This 1943 map shows the now-unused Chicago, Milwaukee, St. Paul & Pacific tracks, often called the Milwaukee Road, cutting northeast through Lake View. The tracks ran north on Lakewood Avenue past Peerless Confection (not shown). When the tracks reached Belmont Avenue, they angled northeast, serving other industrial sites until they reached Wrigley Field. (Courtesy of the City of Chicago.)

The Milwaukee Road no longer runs this far north, but the railroad's path resulted in a number of odd housing configurations like this one. These houses, on the west side of the 3300 block of North Racine Avenue, angle into the block, following where the railroad formerly ran. (Photograph by author.)

Six

SECRETS OF LAKE VIEW

Brick factories converted into condominiums are generally unremarkable. And, while Regal Lofts on Diversey Parkway may not warrant a second look by the average bystander, the building holds a secret: it was the scene of a murder in 1897 that riveted Chicago. Adolph Luetgert, a sausage manufacturer, was accused of killing his wife and grinding her into meat in the building. The case sent sausage sales plummeting, grew into an early media sensation, and ended with a controversial verdict.

Many other tales of mystery lurk in Lake View's buildings. These stories are fading from memory, as are the stories of some of the neighborhood's people. The area's German and Swedish heritage overshadows groups such as the Lucchesi, emigrants from Lucca, Italy, who settled around Wrightwood and Clybourn Avenues. These residents were once an obvious presence, with an Italian deli on Ashland Avenue (now El Presidente Restaurant) and a cheese-rolling contest down Paulina Street.

More obscure than the Lucchesi were the Kashubs. Even describing this ethnic group is difficult because their origin is subject to debate. They emigrated from the German-Polish borderlands, settling around Fullerton Avenue in the late 1800s. They founded a church still known to this day as a historic Kashub outpost in the New World.

Another group that populated Lake View around Southport Avenue were Gypsies, or Roma. Sometimes they were not welcomed, and there were ugly suspicions about theft. This characterization was unfair, according to Donny DeMarco, who says the prejudice irks him. But it is a moot point; like so many Lake View old-timers, the Gypsies are gone.

On May 1, 1897, Louisa Luetgert, the wife of Adolph Luetgert, the owner of the A.L. Luetgert Sausage & Packing Co., disappeared. At first, the sausage king said Louisa had gone to visit her sister, and then he said she had run off with a man. The police grew suspicious and then discovered that Mr. and Mrs. Luetgert had been seen entering the factory on the night of May 1. (Courtesy of Robert Loerzel.)

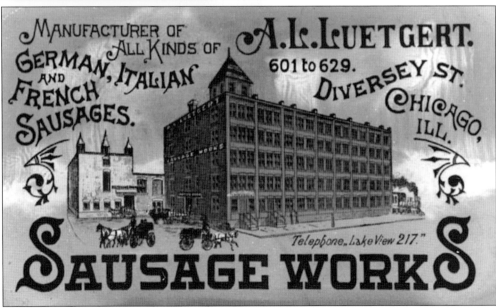

Police searched the Luetgert factory and discovered some bone fragments in a vat and two rings, one with the initials "L.L." Authorities, believing Adolph had killed Louisa and dissolved her body, charged him with murder; meanwhile, horrified sausage eaters swore off the meat as rumors spread, falsely, that she had been ground into a Luetgert product. (Courtesy of Robert Loerzel.)

Amid intense newspaper coverage, Adolph Luetgert maintained his innocence and seemed unworried. The trial ended in a hung jury, but Luetgert was tried again, with the prosecutors calling forensic experts, then a novel practice, to identify the fragments as human bone. He was found guilty, though the verdict was criticized because the victim's body was never produced. (Courtesy of Robert Loerzel.)

It was long thought that the sausage factory burned down, but writer Robert Loerzel, when researching his book *Alchemy of Bones*, discovered that the building (seen here) still stood at the southwest corner of Hermitage Avenue and Diversey Parkway. It has been converted into condominiums, and any traces of sausages and the murder are long gone. (Photograph by author.)

The Brundage Building, at 3301 North Lincoln Avenue, has enjoyed more than its share of fame. It was built by Avery Brundage, who later led the International Olympic Committee. A number of movies were filmed there as well, including *Hoodlum*, starring Laurence Fishburne, *Straight Talk*, starring Dolly Parton, and *Baby's Day Out*. It now houses condominiums and the Chicago Photography Center. (Photograph by author.)

For years, the Brundage Building held Harry Starr's safe-deposit firm and its vault. In 1978, burglars pulled off what was described at the time as a roughly $1 million heist. Starr, aged 88 and a longtime neighborhood figure, said the safe was locked and working properly before the burglary. There were suggestions to the contrary, but he insisted, "Nobody opens that vault nor closes it but Harry Starr." (Photograph by author.)

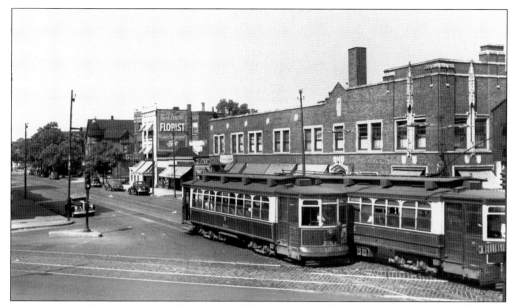

Streetcars pass by P.A. Birren & Sons Funeral Home in 1947. The Southport streetcars converted to buses that year, and the bus line eventually ended in 1973. The history of the funeral home goes deep into Chicago's past. It was founded in 1859, burned in the Great Chicago Fire in 1871, and remained in the family, in different locations, until the 1980s. (Courtesy of Joseph Herdegen.)

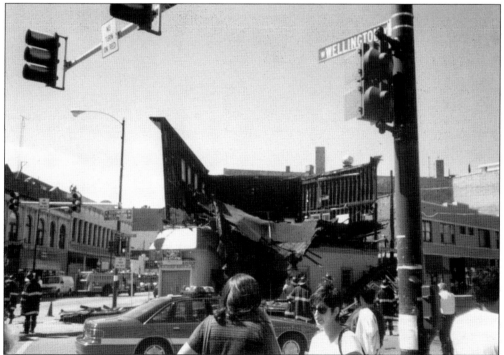

This Chinese restaurant caved in during the 1990s on the northwest corner of Southport and Lincoln Avenues, where they intersect with Wellington Avenue, according to Joseph Herdegen, whose funeral home is across the street. Pockets Restaurant is in the space now. (Courtesy of Joseph Herdegen.)

Geno Neri enjoys a "cold one" outside the Miami Tavern, which was once at the northeast corner of Paulina Street and Wrightwood Avenues, the center of the neighborhood where emigrants from Lucca, Italy, came. Neri moved to the neighborhood as a boy and stayed there, working as a fence builder. (Courtesy of Dennis Neri.)

Geno Neri's son Dennis recalls a family story about his father betting he could push his car around the block. This appears to be the proof that he really did it. (Courtesy of Dennis Neri.)

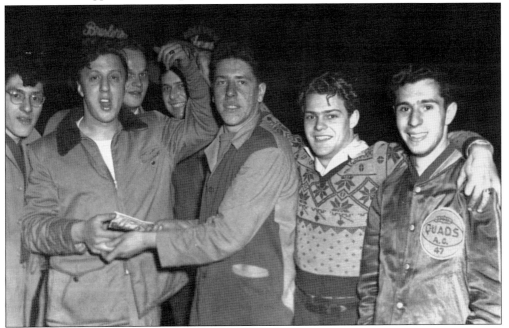

A triumphant Geno Neri (second from left) appears to collect on his bet from one of the young men watching him in the previous photograph. (Courtesy of Dennis Neri.)

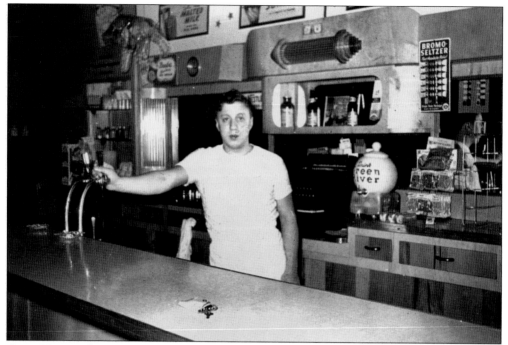

Geno Neri works at his father's soda fountain on the southeast corner of Wrightwood and Marshfield Avenues. Geno's father, like a number of Italians, went first to the mining towns of Michigan's Upper Peninsula before coming to Chicago. (Courtesy of Dennis Neri.)

Mario Bargi (center) socializes outside the Miami Tavern. This photograph was probably taken not long after World War II. (Courtesy of Dennis Neri.)

Eufamia Neri, Geno Neri's mother, cleans up outside the Miami Tavern. This photograph was taken looking north on Paulina Street, with Wrightwood Avenue behind the photographer. Note the lack of houses on the street in the distance. (Courtesy of Dennis Neri.)

Annie Mei and her cousin Gemma Mei pose for a photograph outside the Northwestern Terra Cotta Co. factory in the 1950s. The factory drew many immigrants and gave its name to the neighborhood, which is called Terra Cotta. (Courtesy of Norma Ehrenberg.)

Norma Ehrenberg steps outside of her childhood home at 2632 North Ashland Avenue on her wedding day in 1953, accompanied by her parents, Nick and Annie Mei, her sister Dolores (right), and an unidentified woman. (Courtesy of Norma Ehrenberg.)

A Halloween party is taking place here at Norma Ehrenberg's house in the Terra Cotta neighborhood in the 1960s. From left to right are Nick Meyer, Frank Alterio, Loraine Alterio (as a flapper), and George Ehrenberg. (Courtesy of Norma Ehrenberg.)

Nella Parenti (third from right) is seen here visiting cousins near Lucca, Italy. She came to Chicago on July 4, 1927, at age 17. Her sister Josephine Fanucchi, who was three years old at the time, came with her, and they have lived in Lake View ever since. Parenti prefers the United States to her native Italy, saying, "I miss it because I was born there, but America is the best." (Courtesy of Nella Parenti.)

Nella Parenti embraces her nephews Dennis and Norman Papucci on the 2500 block of North Marshfield Avenue around 1940. She has lived in the same house since that year. She went to work in 1949 at the N. Henry & Son banner factory at Cortland Street and Ashland Avenue. She did not retire until 2004, when she was 94 years old. (Courtesy of Nella Parenti.)

Sisters Josephine Fanucchi (left) and Nella Parenti, who is now over 100 years old, are seen here in 2013 attending St. Bonaventure Catholic Church, at 1625 West Diversey Parkway. A statue of St. Gemma Galgani, who came from Lucca, stands behind them. (Photograph by author.)

This building, on Terra Cotta Place near Clybourn Avenue, was once part of the Northwestern Terra Cotta Co. The company, founded in 1878, employed 1,000 workers in its Chicago plant. It made decorative moldings for structures, including the Wrigley Building and the Civic Opera House. (Photograph by author.)

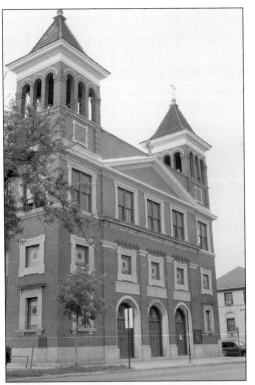

St. Bonaventure Catholic Church was founded in 1911 and recently survived a near-death experience. Like other Catholic churches, its membership suffered as residents moved out. Unlike other churches, though, its school also closed, taking away parents and worsening its losses. St. Bonaventure was saved from closing by being reclassified as an oratory, not a parish, and is gaining members. (Photograph by author.)

This photograph shows 50 children filling Room 8 at St. Bonaventure's school in 1949. While St. Alphonsus was known as a German parish, St. Bonaventure had families from a wide variety of ethnic backgrounds, including Irish, Italians from the Terra Cotta neighborhood, and later Hispanics. (Courtesy of St. Bonaventure Catholic Church.)

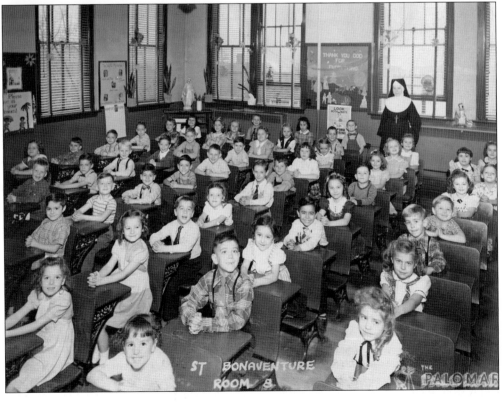

A crowd gathers for a wartime ceremony around 1942 at Wrightwood Avenue and Altgeld Street. Nick Mei, one of the emigrants from the Province of Lucca, which is in Tuscany, ran the Toscana Tavern. The name can be seen in the window of the corner building. He had previously bartended at the Lakeview Pleasure Club, whose banner is in the crowd. (Courtesy of Norma Ehrenberg.)

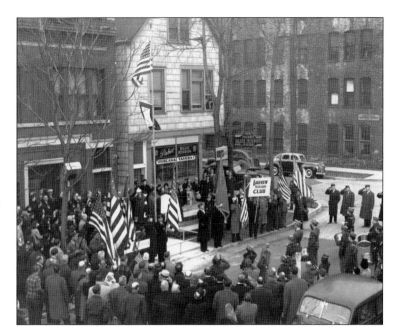

Seven decades later, Augie's Bar has taken the place of the Toscana Tavern. The flagpole still stands, though with peeling paint. Nick Mei's daughter Norma Ehrenberg remembers when businesses dotted the side streets of the dense neighborhood. Within a block of her, she said, there was a candy store, a butcher shop, a grocery store, and an ice cream parlor. (Photograph by author.)

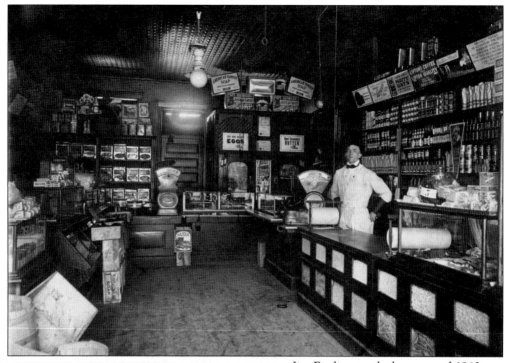

Jim Fredian tends shop around 1940 at his Centrella grocery, at 2507 North Marshfield Avenue. Fredian (originally Frediani) rose at 4:30 a.m. to buy vegetables at the Fulton Street Market and bread from Gonella and would sometimes work until 10:00 p.m. Alan Fredian recalls that when his father needed change, he would send Alan to the tavern next door, where a bookie served as the neighborhood banker. (Courtesy of Alan Fredian.)

This is one of the houses on Terra Cotta Row. It is not in the Terra Cotta neighborhood, but it has a direct link to it. It is one of four houses at Oakdale and Seminary Avenues that were built for executives of the Northwestern Terra Cotta Co. This one, the Henry Rohkam House, at 1048 West Oakdale Avenue, has an unusual terra-cotta wall in front of it. (Photograph by author.)

This mansion, at 4223 North Greenview Avenue, was built for Frederick Sulzer, the son of Lake View's founding father Conrad Sulzer, in 1888. It stayed in the Sulzer family until the 1950s. Actress Joan Cusack and her husband, Richard Burke, bought it in 1998. They sold it in 2007 for $4.7 million. (Photograph by author.)

Rock star Billy Corgan lived in this Victorian painted lady at 3448 North Greenview Avenue. Corgan, the lead singer of the Smashing Pumpkins, grew up in west suburban Glendale Heights. He sold the house in 2001 after it did not turn out to be the sanctuary he had hoped, according to the *Chicago Tribune*. His real estate agent said that he deliberately sought a buyer who would not tear it down. (Photograph by author.)

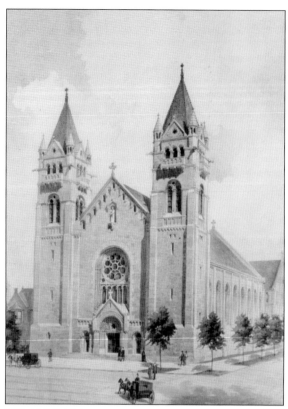

St. Josaphat Catholic Church dates to 1882, but construction began on the current building, seen here at 2311 North Southport Avenue, in 1899. The parish was founded by Kashubs, who lived under German rule near Danzig (now Gdansk, Poland). The group, which has its own Polish dialect, did not want to worship at the nearby German or Polish churches, so it started its own parish. (Courtesy of St. Josaphat Catholic Church.)

Construction of the church met a severe setback in 1900 when a cyclone toppled a steel framework. This photograph appears to show the aftermath of the storm. The parish rallied, started work again, and celebrated its first Mass in the new building in 1902. (Courtesy of St. Josaphat Catholic Church.)

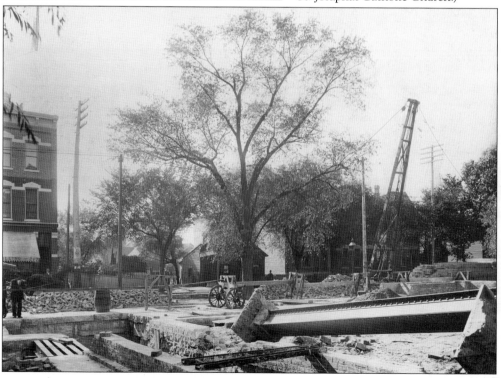

This advertisement in a St. Josaphat publication indicates that Herman Groya of Greenview Avenue was selling Kashub tobacco. Snuff is a Kashub tradition, and a recent attempt by Poland to ban the substance resulted in an uproar in the Kashub region. (Courtesy of St. Josaphat Catholic Church.)

Mary Slawikowski (later Pokryfke) stands behind 2552 North Southport Avenue. The Slawikowskis were a Kashub family, and Mary's son Jim has seen an ancestor's military papers in German, signed by the Kaiser. Mary, born in 1916, lives today in Des Plaines. (Courtesy of Jim Pokryfke.)

Many Gypsies once lived around Southport Avenue. Here, Douglas Yedla (left) and Donny DeMarco goof around outside Huck's Meat Market, at Southport and Barry Avenues, in the 1960s. DeMarco fondly recalls Lake View but still bristles at some memories. A policeman once taunted him by singing, "Gypsy Woman," he says. "I just had to close my mouth and listen to it." (Courtesy of Donny DeMarco.)

From left to right, Jimmy Garver, ? Ziga, and Tommy Ballog put on their best for Easter Sunday in the 1970s. Many Gypsies attended St. Alphonsus Church, where DeMarco says they were welcomed. (Courtesy of Donny DeMarco.)

Violinists gather for the Gypsy wedding tradition of playing outside the bride's house in 1989. Donny DeMarco's niece Sue Polo and her father, Louis Polo, are coming out of their home on Ashland Avenue near Addison Street. (Courtesy of Donny DeMarco.)

Young musicians gather at a home near Southport and Barry Avenues. The middle three boys are, from left to right, Ricky Montana, Vince Chase, and Dave Stone. In the Gypsy tradition, each went on to become a professional musician, DeMarco says. DeMarco himself is a professional pianist and singer, and his father, Al DeMarco, was a noted orchestra leader in Chicago. (Courtesy of Donny DeMarco.)

Only a stone engraving hints that a Kresge department store once stood on Lincoln Avenue near School Street. The building now houses the Wishbone Restaurant and Building Blocks Toy Store. (Photograph by author.)

Harry Blesy grew up at 1918 West Wolfram Street and worked the Spill the Milk concession at Riverview Park in 1961, when he was 17. He took this photograph from the concession's roof, where he would gather coins that fell out of the pockets of people on the Roll-O-Plane ride. (Courtesy of Harry Blesy.)

This old firehouse at Byron Street and Hermitage Avenue has opaque windows and no sign. It is the location of the police detail that guards Chicago mayor Rahm Emanuel, whose house is nearby. (Photograph by author.)

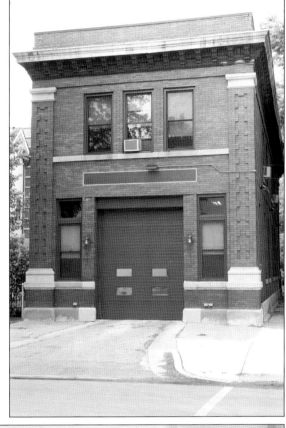

From left to right, Hank Mujica, Aggie Blesy, and Harry Blesy enjoy a bite around 1970 at Man-Jo-Vin's, at 3224 North Damen Avenue. Harry Blesy remembers that the restaurant, which dates to 1953, had gigantic cones for merely 25¢. It was named after the founders, Manny, Joe, and Vince Nuccio. (Courtesy of Harry Blesy.)

Discover Thousands of Local History Books Featuring Millions of Vintage Images

Arcadia Publishing, the leading local history publisher in the United States, is committed to making history accessible and meaningful through publishing books that celebrate and preserve the heritage of America's people and places.

Find more books like this at
www.arcadiapublishing.com

Search for your hometown history, your old stomping grounds, and even your favorite sports team.

Consistent with our mission to preserve history on a local level, this book was printed in South Carolina on American-made paper and manufactured entirely in the United States. Products carrying the accredited Forest Stewardship Council (FSC) label are printed on 100 percent FSC-certified paper.

MADE IN THE USA